For my children and grandchildren

Rupert,
Araminta,
Katie,
Alexander,
Rory,
Ella,
Iggy,
Abel,
May,
Ava,
Freddie,
Elsie,
and
Barney

THE ART OF
GERALD
SCARFE

Written by Gerald Scarfe

Foreword by Thomas Schumacher

INSIGHT
EDITIONS

SAN RAFAEL · LOS ANGELES · LONDON

TS

Foreword:
A Herculean Visionary

By Thomas Schumacher

Above: Thomas Schumacher.

Opposite: One of the strong images that came to represent the movie of *Pink Floyd: The Wall*. This painting was used in much of their advertising and on the main poster.

WHEN I SPEAK OR WRITE about my tenure at Disney Animation, I remind my audiences that it was always, and remains, all about the people. Disney animated features are so full of *life*, it is often hard to reconcile that those are just rapidly moving drawings—24 per second—that create "the illusion of life." The "life" comes from the remarkable people who create the images. And that's never been truer than with Gerald Scarfe on our 1997 film *Hercules*.

Gerald's artistic impact on the film can't be overstated, so much so that he went from an initial assignment as an "inspiration artist" to credited "production designer." That's the only time I can remember that happening over the 21 animated features on which I worked.

When Disney animator Joe Haidar pitched the idea of *Hercules* as the subject of a film, it seemed like the most absurd idea we'd heard. A historical drama about a big strong guy? But it was directors John Musker and Ron Clements who were able to imagine the screwball comedy/action-adventure/musical we made. Alan Menken and David Zippel's Gospel-inspired song score has countless plays on all platforms, and their Oscar®-nominated song "Go the Distance" has become an American standard.

Even so, it is the *look* of the film that most separates it from the field. The boldness of the illustrative style pushes the look of the film beyond what critics and audiences alike thought "Disney" should look like. And that willingness to be bold set a standard for several gorgeous films to follow.

But Gerald Scarfe? The iconoclastic political caricaturist, visualizer of Pink Floyd's *The Wall*; cartoonist for *Punch*; the *Evening Standard*; *The Daily Sketch*, and the *Sunday Times*; *Time* magazine cover artist, sculptor, designer of sets for operatic productions?

(This renowned maestro of the pen has even created a set of commemorative British postage stamps!) How did he end up in Burbank? Like everything great at Disney Animation, it started with the question, "What if?"

That particular question was posed by visual development artist Rick Maki to John Musker, who, along with his directing partner Ron Clements, had already delighted the Disney fandom with both *The Little Mermaid* (1989) and *Aladdin* (1992). Maki thought Gerald's style would be a good complement to the visual development team. Legendary caricaturist Al Hirschfeld had come to Disney Animation during the early days of development on *Aladdin* and "inspired" the look of the character designs. Perhaps something could be worked out to bring Scarfe on board? It turned out that since his youth in Chicago, Musker had been a huge Gerald Scarfe fan—and so he jumped at the idea.

It was an easy sell to me and to Peter Schneider, who were running the joint at the time. The bold gesture was just what the film might need. What we didn't know is how *big* Gerald's contribution would become. Every human character, fantasy character, monster and what-have-you in the film has been touched or influenced by Gerald. He worked directly with the animators (working on both hand-drawn and computer imagery) to partner on the style.

Gerald worked, typically in ink and watercolor, on large-format sheets, about 23 by 33 inches in size, and one of my assignments during the early days of his work was to swing by his home studio on my way to the airport for a flight back to the States, after a week of work on another project in London.

"And this artwork changed Disney Animation forever."

—Thomas Schumacher

When I first looked up at this full wall of top-to-bottom, side-to-side color illustrations, I thought I was going to fall over. It was nothing short of thrilling—like being on a beach with a giant wave of color and line about to overwhelm me. I couldn't believe how he'd captured the tone and character of what the film could be.

We shared a stepladder as we took down the drawings, which had been attached to the wall with little balls of sticky putty, and placed them gently in a large artist's portfolio for transport. There were certainly more than twenty-five of them. It was a magnificent collection.

After a cup of tea and perhaps a biscuit, I got in a car and was taken to Heathrow Terminal Four, which in those days housed the now-defunct Concorde supersonic airplane.

Now, the thing about the Concorde was that you couldn't carry anything on the plane other than a small purse or folio. Not even a coat—those went on a rack before you boarded. But I was carrying this jumbo-size portfolio of drawings, and it certainly could not be checked as luggage, and it wasn't going to fit on the very cramped plane. (And, frankly, what in heaven's name was I *thinking* would happen?)

The Concorde was so expensive, you practically had to get a signature from the pope to be allowed by Disney's Travel Department to fly on it, but I was in a hurry. And this was Gerald's hand-made, one-of-a-kind art!

A kindly flight attendant advised me that I wouldn't be able to board with the portfolio, and I began to panic. The only choice was to throw myself at her mercy. At least the words "Disney Animation" were special enough to get some attention, and it was clear I wasn't budging. My welling eyes and quivering lower lip might have signaled that.

One of the pilots was summoned, and on approaching me in the elegant Concorde lounge asked me exactly what the problem was. I babbled all sorts of film jargon, and urgent pleas about "the pressing need to get back to the studio," and this is rare and priceless original art by this guy named Gerald Scarfe and I simply couldn't just check it as if it were baggage, and . . .

"Did you say *Gerald Scarfe*? Scarfe of Pink Floyd's *The Wall*?!?!" he nearly shouted. I opened the folio. The gobsmacked pilot lifted each art piece as if he were in the conservation lab of the Louvre.

I tucked, relieved, into my seat. Gerald's portfolio got a better one—in the cockpit of the Concorde. And this artwork changed Disney Animation forever.

Thomas Schumacher
Chief Creative Officer, Disney Theatrical Group

How It All Began

EVEN FROM A YOUNG AGE, I've always been a Disney fan. On a trip to Los Angeles in 1979, I made an appointment to see one of the heads of the Walt Disney Company's animation department about my desire to work with the organization. Once seated in the studio head's comfortable office, I found him to be a bit offhand and, upon seeing my portfolio of work, he told me it was not what Disney was looking for. It just wasn't a good fit.

I left his office—humiliated and slightly angry—and declared to the startled secretary in the outer office that, despite this dismissal, I would be working with Disney one day. She obviously thought I was crazy as I stormed out of the office. But I knew that one day I would be working with Disney Animation. I just wasn't sure what form that would take.

And I was right. Fifteen years later, I found myself the first outside production designer ever to work with Walt Disney Feature Animation, on their major film *Hercules*.

Below: Me, Pegasus and Phil.
Opposite: Walt Disney as the Sorcerer's Apprentice, the *New Yorker*, 2006

Throughout the course of this book, I will tell you how my time at Disney came about, and of the relationship between me and the animators—as an outsider inside Disney's highly successful organization. This is primarily an art book, and it will illustrate the journey from my first designs through to the finished film. You will get a glimpse into the artists' reactions to my designs and style. Would employing me work? Or would the filmmakers, like the original Disney executive that I met with in 1979, see it all as an impossibility?

Early Inspirations

From birth, I suffered from chronic asthma, which meant I was bedridden for much of my childhood—missing large periods of schooling and frequently hospitalized. Inevitably, I was a lonely child and lived in my imagination most of the time. We didn't have a television in our house, and I could only access the occasional radio broadcast as my connection to the outside world. I grew up during wartime in London, and since my father was in the forces, my mother and I didn't see him much. It was a very silent world I lived in, much of it in my imagination.

There was no question that the loneliness, unhappiness, and physical discomfort of my constant breathing difficulties influenced my temperament and my outlook on life—producing the propensity of darkness in my work.

I spent hours in bed sketching—often trying to put my thoughts and feelings onto paper. Later in life I found that drawing based on imagination can be elusive. It can be like a dream: Unless you write it down immediately upon waking or you tell someone about it quickly, it evaporates and it's gone. My drawings are sometimes like that. I have to put them onto the paper before I lose the idea, before it's gone . . . before it just disappears into the atmosphere. It is a strange process, one that I don't really understand, but the act of drawing itself and the unloading of my thoughts onto the paper is therapeutic.

Above: The Frightened Ones. I lived through the second world war: much of it in constantly bombed London, where we had to scuttle to safety in air raid shelters when the warning sirens wailed. One of my strong memories of that time was having to wear a gas mask: a tight-fitting rubber headpiece with a muzzle to breathe through. As an asthmatic I found it frightening and claustrophobic to be shut inside: I couldn't breathe! When it came to my designs for Pink Floyd's *Goodbye Blue Skies*—a poem to the Second World War—I remembered this memory and designed these frightened, gas mask-headed creatures.

Top: Lampwick in *Pinocchio*. One of the most truly frightening scenes in cinema. As a child I watched in horror as cigar-smoking 'bad boy' Lampwick turned slowly into a donkey. He grew hooves and a tail; his head sprouted long ears as it turned into a donkey's muzzle. His pitiful, heart-rending call of "Mama! Mama!" as it turned into a chilling bray. Scary? I should say so!

Middle left: Honest John, the fox, from *Pinocchio*.

Middle right: The Queen in disguise from *Snow White and the Seven Dwarfs*. I'll never forget her!

Left: Bambi lost and alone in the forest after his mother is killed.

Disney and Me

As an only child for the first nine years of my life, I found that Disney became very important to me because it was an outlet for my feelings. When *Pinocchio* (1940) was first shown in the United Kingdom, my father took me as a special treat to see it in a cinema on Regent Street. When he went to pay for the tickets, he discovered (to his dismay) that they were seven shillings and six pence each—a lot of money in those days. He said we'd have to wait until it came out locally to watch the movie.

I was devastated. I remember walking up Regent Street, in a flood of tears. My father, seeing how upset I was, relented and we turned around and went to see the film after all. It was wonderful, and I adored every minute of it. Back at home, I copied and drew all the characters over and over again. Still today, to a certain extent, I draw eyebrows like the wicked thespian fox, Honest John, in *Pinocchio*. Disney has had an influence on my life from the very beginning.

Walt Disney became my hero very early on. As I grew, I followed his career in Hollywood and Los Angeles, including all the theme parks he was building. (I thought maybe one day I'd have a Scarfian theme park . . . but it hasn't happened . . . yet!) A few years later, my mother took me to see *Bambi* (1942). At a certain point during the movie, my mother put her hand over my eyes, and I thought, "What's going on?" It was, of course, the death of Bambi's mother. She was trying to hide the tragic scene from me.

While watching a re-release of *Snow White and the Seven Dwarfs* in England, I was really terrified by the witch with the red apple. Fairy tales can be dark; look at Hans Christian Andersen, Grimm, and so many others—they're horrific! When you read the original story of *Pinocchio*, for example, the wooden puppet burns his own legs off while sleeping in front of the fire, and later he's hanged and chopped up into pieces. But, of course, being a fairy tale, everything turns out all right in the end. Everyone lives happily every after and the princess gets to go to the ball . . . but on the way there, it's a bit tough.

That's the main difference between my work and Disney animation: My art is extremely dark and cynical—possibly a reaction against my life up to that point. As things got better for me, I found that I could ease up a bit and bring more light into my work, although the darkness was still there. When it came

> ## "Some of Walt's films had some pretty scary stuff." —Gerald Scarfe

Top: The book cover of my personal copy of *Pinocchio*.

Top: John Musker (center) and Ron Clements in rehearsal with James Woods (left), the voice of Hades.

Above: The seminal drawing of Jackie O that John told me was instrumental in introducing me to Disney.

Opposite: *Time* magazine cover of the Beatles, September 22, 1967.

to working with the Mouse, some people in my life told me that they wondered how an artist with my kind of dark reputation could work for Disney. They saw Walt Disney's work as cute: little bunnies bouncing about, baby deer, wooden toys coming to life, etc. But Disney animation is not all that way. If you look at the body of Walt's work, you find some very evil characters, such as the wicked Queen, the Stepmother, and the Witch. In every Disney movie, there is almost always a villain, one who meets their comeuppance in the end. Those are the characters that draw me to Disney.

One might say that it was John, Paul, George, and Ringo, together with Jackie Onassis, who introduced me to the Walt Disney organization. My drawings of those mythical characters and some others were pasted into the scrapbook of a 14-year-old student in Chicago. That young man just happened to be John Musker, who would go on to become a highly successful director at Disney, creating some of the many iconic classics such as *The Little Mermaid* (1989) and *Aladdin* (1992).

Apart from my drawings in John's scrapbook, Musker had also seen a 1969 exhibition of my work at the Sears Vincent Price

Top: A backcloth from *The Magic Flute* used in a scene where Papagena and Papageno are tested by fire. I have used fire several times in my designs: Pink Floyd's The Wife's hair, as well as for fiery Hades himself.
Above: Me and the Tigoon—half tiger, half baboon—from *The Magic Flute*, 1995.
Opposite: Poster for *The Magic Flute*, Los Angeles Opera, 1995.

Gallery in Chicago, and many years later remembered me when he was about to direct Disney's feature-length animated movie *Hercules* (1997). It struck him that I might be able to give his film a "new look."

Musker then arranged for Rick Maki, a Disney visual development artist, to visit me in London. Before he came, I had assumed that, as a fellow artist, he was just interested in seeing my studio and my work. But I soon realized that perhaps he had been sent to sound me out for Disney. He began to ask me questions like, "Would I ever work for Disney?" And I said, "You bet. I'd love to." After Rick went back to Disney, John Musker wrote to me about this new movie called *Hercules* and asked if I'd like to be involved in any way. This was fantastic news! Naturally, I said yes. I soon flew to Hollywood to meet John and his directing partner, Ron Clements.

So that's how working for Disney came about—all serendipity. I couldn't have planned it better myself, or even foreseen it happening. Well, as a matter of fact I did predict it when I told that secretary at Disney all those years ago that I was going to be working here one day.

"My first visit to an underworld." —Gerald Scarfe

The story of Hercules is heavily involved with Greek mythology, Mount Olympus, and the underworld. Oddly enough, I'd already worked on designs for all of these concepts for a well-known operetta: *Orpheus in the Underworld* by Offenbach, a satirical version of the Orpheus story based on a serious opera by Christoph Willibald Gluck.

These are three drawings of scenery and costumes for the production.

The Seven Judges
of Hades

Top: Costume design for Mars, the god of war for *Orpheus in the Underworld*, 1985.

Above: Mars on stage, 1985.

Right: Poster for *Orpheus in the Underworld*, 1985.

Opposite top: Zeus had a persistent habit of disguising himself as various animals to court attractive women: With Leda, he was a swan; with Europa, he was a bull—and so on. Zeus's wife, Hera, was not at all happy with this, to put it mildly. We ran this joke in the Orpheus opera, to the audience's delight, but Ron and John didn't think it the right fit for *Hercules*.

Opposite: Zeus caught by his wife with his elephant trousers down.

Scarfe and Animation

In 1968, I first used animation for a sequence in a BBC short film for a series called *One Pair of Eyes*. I called my episode "I Think I See Violence All Around Me," and I used stop-frame animation for the piece. This short film entailed a rostrum camera, loaded in those days with 35mm film, pointing down at my paper while I was drawing. I would draw the beginning of a line, take my hand out of the way while the well-known camera operator, Ken Morse, would shoot two frames, and then add a little more to the line. Again, hand out of the way and two more frames shot, and so on until the drawing was complete. Thus, when one watched the film in one go, the line would appear to move by magic, and the picture would gradually appear on the page.

Later on, when the BBC asked me to design the titles for *Yes Minister*, a brilliant piece of satire on British politics, I drew caricatures of the principal actors, once again animated by using the rostrum camera technique.

Below: *Yes Minister*. It's still running on television around the world to this day.

Opposite: *Long Drawn-Out Trip*. I found it difficult to draw directly onto 70mm film, which offered a drawing area of only 3″ x 4″. Very small for me. These strips show the evolution of man from the fish emerging from the water through a lizard into an ape-like creature.

Nick Park—of *Wallace & Gromit* fame—utilizes the same principle when he alters his little clay figures frame by frame.

Then, in 1972, the BBC sent me to Los Angeles to try out a new animation process: the De Joux system, which would do half the work of animation automatically. To cut a long story short: It didn't. But since I was there anyway, I decided to go ahead and work on this patent "machine." Two rolls of 70mm film were inserted into the gadget, enabling me to draw directly onto a frame of each roll alternately. The film itself then had to be photographed, and the BBC had the idea to automatically cross-fade from one set of pictures into the next, giving the appearance of movement. It didn't save any work, but I found myself beginning to enjoy the challenge of drawing onto such a small canvas.

So, I had the idea of making a short film all about the United States, calling it *Long Drawn-Out Trip*. I drew hundreds and hundreds of tiny pictures onto the frames, including every American image I could think of: from the Statue of Liberty to Black Power; from *Playboy* magazine to Cadillacs and Nixon; from John Wayne to—of course—Mickey Mouse. They all morphed into each other with the assistance of the De Joux system. I added color and sound to the film and took it back home, where it was later shown on the BBC.

Above: Me and Nick Park in Walt Disney's old original office in 2018, where everything, including furniture, books, pens on Disney's desk, are preserved in their original positions: the way they were when Walt last worked there. I asked if I could sit in Walt's chair for a photograph, and they said certainly not—it is far too sacred, even more so now that these pieces are viewed as "museum objects." So is my backside.

"Whatever the prize, sometimes you've just got to have it." —Gerald Scarfe

Above left: Award for first place film in my category.

Above right: My satirized rendition of Mickey Mouse seen in *Long Drawn-Out Trip*, 1973.

Opposite: Gerald Scarfe showing 70mm film from *Long Drawn-Out Trip* 1973.

As it turned out, *The Long Drawn-Out Trip* was up for a prize at a film festival in Zagreb, in what was then Yugoslavia, under President Tito. The setting and the auditorium itself where the films were to be shown was gray, dismal, and typical of the communist architecture of that era. The prizes themselves were displayed in a glass case in the foyer, and they were dreadful: First prize in my category was a wooden cutout cartoon head, with a smile on its face and its eye painted on as if by a child. It was set on wooden wheels with string attached like a child's toy.

But human nature and the instinct to win took over, and, as the days of the festival passed and judgment day neared, I began to yearn to win this ridiculous toy. It went from looking like junk to being intensely desirable, and by the final day I had to have it.

And I did! I won the award for first place film in my category and brought the prize back to London. I gave it to my young daughter, Katie, to pull around.

The Wall

When it aired on the BBC, two members of Pink Floyd saw *Long Drawn-Out Trip*, and the next morning asked each other if they'd seen it. They said, "We've got to have that guy work for us—he's f***ing mad!" And thus began our work together. A small team of animators was hired and began laboring away in my house in Chelsea for several months, producing some of the surreal animated images that were to be shown on a large circular screen during Pink Floyd's Wish You Were Here concerts. Through working with the band on their tour, I became close friends with them—almost like a fifth member of the band.

Sometime later, bassist Roger Waters came to my house with the raw tapes of a project he'd been writing, called "The Wall." He said it would become a record, a live show, and a film, and that he wanted me to help him with some ideas and designs to create an animated film that would accompany the band's concerts. This became a big operation, with a greater number of animators for me to now direct.

Not long afterwards, MGM green-lit the film version of *The Wall*. Roger brought me in as the production designer for the film. In addition to overseeing the look of the film, I was called upon to create additional animation. Eventually, I had dozens of artists working full time in London on the project with me, in a huge studio in Covent Garden. It was a wonderful power to have: to be able to pluck characters from my imagination and have a team of highly skilled artists bring them to life. This is what I call the "Pygmalion Effect."

> **"There's all sorts of tricks you can play with animation. It's the most magnificent tool. It's magic."**
> —Gerald Scarfe

Opposite from the top: Part of the animation sequence for "Empty Spaces", which became "What Shall We Do Now?" in the film.

Flower sequence: colored pencil on paper (left) and an animation cel from the beginning of the sequence.

Snaring with hatred and accusation (animation cel and watercolor composite of the scorpion wife, left) and my vision of the wife bearing down on the horrified Pink (gouache on paper).

The Marching Hammers were my interpretation of the unforgiving, brutal force that is fascism. It came to me at the very beginning of designing *The Wall* that I needed something vicious and cruel to symbolize the blindness of its force. This is a recent painting that sold in 2021 at Sotheby's (oil on canvas).

Below: *I Think I See Violence All Around Me*. A film I co-directed with John Irvin for the BBC, telling of my feelings about the violent world we live in.

I've always possessed an urge to bring my illustrated characters to life, in any way possible. In the famous Greek mythological story of Pygmalion, a skilled sculptor one day chiseled a life-size ivory statue of a beautiful young woman. He fell in love with the statue and longed for her to come to life. As he pressed himself against her hard, cold, ivory body, Pygmalion prayed to the goddess of love, Aphrodite, that his beloved statue could be warm and soft, and she granted his wish. He may have had impure thoughts and bad intentions, but let's give him the benefit of the doubt. Maybe Pygmalion was just an artist who loved his work that much.

Without the goddess Aphrodite to lend me a hand, rostrum animation was one way of getting my work to move, and costuming actors for stage or screen was another. Geppetto in the film *Pinocchio* (1940), of course, achieved this magnificently with his wooden puppet, but with the magical help of the Blue Fairy. In our real world, computers can animate any drawing or photograph with just a few clicks, and artificial intelligence (AI) will soon make it difficult to tell what is real and what exists only inside the creator's animation. But for me, nothing has come as close to bringing life to my work as hand-drawn animation for the big screen.

I've made many mistakes in my work throughout my career. But art can be a forgiving discipline. Whatever an artist produces, the viewer tends to assume that it's intentional. If an eye in a drawing looks as if it's in the wrong place, then that must be what the artist meant to do. However, that isn't always necessarily the case.

During my research for *Hercules*, I spent many, many happy days drawing at the British Museum. Here are the statue of Dementer (opposite) and other sketches made at the time.

Top right: The copy of the horse of Selene that I bought at the British Museum. I discovered a small chip on his nose and asked for and got a reduction in the price. Cheap Jack! I love it: He still stands in a corner of my studio.

"I do everything instinctively. I just think, 'What does this character look like? What does he feel like?' I almost act and become the character, rather like the animators do. I just want to feel what the characters feel without working it out too intellectually."—Gerald Scarfe

Top: Two Greek vases, showing Herc wrestling with a lion.

Opposite: Hercules Wrestles with the Nemean Lion. My drawing in the style of an ancient Greek vase.

Getting Started

My feelings on agreeing to work on *Hercules* were a mix of jubilation and excitement. I was so keen to do it! Before I joined the production team in 1990, the crew had been busy working away on the script, music, storyboard, characters, etc.— exploring many different ideas and directions for almost a year. The lead artists and animators had all been to Greece for inspiration, and I unfortunately missed out on that trip, but it was made very clear from the beginning that the film should have my signature artistic look and feel to it. Disney wanted to change gears from the usual stuff, and that's where I came in.

The directors, Ron Clements and John Musker, had endeavored to collect as many thoughts and ideas as possible, so there was a wealth of material when I arrived to meet them both at the Disney animation studio. However, I tried to ignore it as much as I could. I wanted to approach the characters without preconceptions and with a fresh mind to give them my unadulterated attention. Then I was to go back to London with as much material as possible and work in my studio on designs for all the characters that would appear in the film.

This was my dream job! The themes and story of Hercules fit into my life in so many ways, and I'd always been very keen on Greek art—fascinated by mythology. And on top of all that was my love for cinema. Encouraged by my visit with the Disney animators, I set forth on a vast sea of possibilities with incredible excitement and enthusiasm—working day and night as the ideas and designs poured out of me. I was finally working "with" Walt Disney, my childhood hero.

Early on, the directors had sent me a script, but it wasn't clear how the story was going to develop or exactly who the characters were in this Disney version of the classic myth. But this uncertainty was right up my alley: I love the moment when the character I'm drawing becomes clear to me. It doesn't exist at first, but giving it more thought, it finally arrives, and I'm thinking, "Where have you been? Why was it so difficult? That's so obvious!"

> "When I was working on Offenbach's *Orpheus in the Underworld*, Jupiter—the Roman version of Zeus—was much lighter as a character. So I learned how to take the mythology I had learned and lighten it up."
>
> —Gerald Scarfe

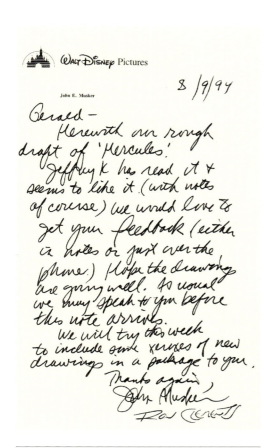

Above: The first day I met John Musker and Ron Clements at Walt Disney Animation Studios, John was thoughtfully wearing my Rolling Stones T-shirt. John and Ron were the most relaxed, laid-back guys: Charming, helpful, and easy to work with. They immediately encouraged me to start work on exploratory designs, and then, Jeffrey Katzenberg, former chairman of The Walt Disney Studios, finally sent me the script (with the above note from Ron and John attached).

Right: A still from the animated film itself.
Opposite: The illustrated script, showing the marvellous planning detail intended for the film.

Mythical Character Explorations

Hercules himself may have been born of Greek myth, but the designs for the Disney version of the character—as well as many members of his divine supporting cast—first manifested in the halls of a fundamentally British institution. I found inspiration for my earliest sketches of the animated Hercules while studying the Greek art on exhibit at the British Museum in London.

From busts and statues of Herakles himself to vases depicting scenes from our hero's most legendary trials, the British Museum's wide array of Hellenic artifacts allowed me to immerse myself in the original art of the period. This resulted in a distinct "neo-Grecian Scarfian" style for my art. With sharp lines, strong angles, and classical figures unlike those seen in any Disney film prior, it felt almost as though ancient etchings had somehow leapt to life from the side of an urn and made their way onto the big screen.

I started with the main characters, the most exciting ones. And because I loved Hades, the bad guy, I immediately went straight into drawing him. Who's really interested in the boring old hero? It's the villain many people want to see come center stage.

I knew where I was with Hades. He's a devil, he's bad, and he's up to wicked things all the time, so I felt at home with him. I soon came up with the idea of representing him through fire.

4 PP

INT. O'LLS/NIGHT

CONFIDENTIAL

FADE IN:

INT. MUSEUM - NIGHT

We slowly TRUCK PAST imposing statues of ancient Greek Gods
and heroes, all dramatically lit. Offscreen NARRATION, a
dignified, resonant woman's voice, begins...

 VOICE (O.S.)
 Long ago, in the faraway land of
 ancient Greece, there was a
 golden age of powerful Gods and
 extraordinary heroes...

CGI?

We TRUCK IN on a beautifully decorated vase depicting a
muscular figure wrestling a lion.

 VOICE (O.S., CONT.)
 And the greatest of all these
 heroes was the mighty Hercules,
 the strongest man who ever
 lived. Though of course, heroes
 must be measured not by the size
 of their strength, but by the
 strength of their hearts. Which
 brings us to the story we are
 about to...

The CAMERA HESITATES, looking for the source of the voice.

 VOICE (O.S., CONT.)
 We... are about to... AHEM!
 ...Down here!

ZIP PAN TO

The CAMERA ZIPS over to another vase, decorated with the
painted figures of five lovely WOMEN in long robes. As we
move in on one of the figures we see that one of them, CALLIOPE,
tall and regal, is alive. A moving illustration on the vase.
As she speaks, we realize the offscreen voice was hers.

 CALLIOPE (CONT.)
 Which brings us to the story we
 are about to tell. We are the
 Muses! Goddesses of the arts
 and proclaimers of heroes!
 Ladies!

The other women, come to life and turn toward Calliope.

 CALLIOPE (CONT.)
 Front and center! Names and
 specialties...

1

With Zeus, I started with some drawings—quite realistic at first. I wanted him to look powerful—as the father of the gods and almighty—so I drew him that way. Whereas when I was working on Offenbach's *Orpheus in the Underworld*, Jupiter—the Roman version of Zeus—was a much lighter character.

When I came to tackle Hercules, the good guy and the main lead in the film, I had a difficult time. I had a hunk in mind, but not the Disney-type of hunk that the studio envisioned—I saw a more regal hero, like the ones you can find at the British Museum—those wonderful archaic statues of Greek men. So I went to the museum again and studied Greek faces, and I began gradually to see a Hercules in my head. It was decided by the directors that he should be something of a cross between Paul Newman and Elvis: a good-looking hunky, muscled guy. He wasn't going to be the brightest guy in the sky, but he was going to be likable.

After many months working alone in my London studio, sending the occasional drawing by fax to Los Angeles, it was finally time to meet the animators.

ATHENA

Opposite: My invitation to Santa Barbra to show the animators my drawings for the very first time.

Santa Barbara and the Animators

Disney had booked a conference room at the Four Seasons hotel in the beautiful seaside resort of Santa Barbara.

I spread my initial designs on the giant conference table and the animators all gathered around, silent at first, but soon growing interested and gradually starting to chat and point. I was extremely nervous and felt vulnerable. I had just unveiled a year's work in front of complete strangers—I felt as if I were stark naked before them. They later told me that they were equally apprehensive, worried that I might be critical of their drawings and also uncertain about being able to adopt my style of draughtsmanship—aware that it was quite alien to their usual Disney style. But overall, they were very kind to me and treated me like a grand old man of the arts.

Apparently, this meeting was an inspiration for them, too. It made them think outside their Disney box, even for two seconds. I pushed them, together with the directors, into thinking in a different way about what the characters could be. And the animators came to see how my style could work once I simplified my designs.

They left that initial meeting with copies of my drawings and later offered their own interpretations of what I had done. Some animators had original ideas that they'd been working on separately, and others just adopted my drawings directly—like Nancy Beiman and the Fates.

YOU ARE INVITED TO:

WHAT?: A RETREAT
WHEN?: JULY 18TH AND 19TH, 1995
WHO?: THE HERC TEAM

RICHARD BAZLEY, RON CLEMENTS, ANDREAS DEJA, TONY DeROSA, ALICE DEWEY,
KEN DUNCAN, BRIAN FERGUSON, RAFFAELLA FILIPPONI, ANDY GASKILL, ERIC GOLDBERG,
ROGER GOULD, KENDRA HAALAND, RANDY HAYCOCK, RICK HOPPE, REBECCA HUNTLEY,
JILL JOHNSON, JAMES LOPEZ, JOHN MUSKER, SUE NICHOLS, NIK RANIERI, GERALD SCARFE,
MIKE SHOW, MIKE SWOFFORD, ELLEN WOODBURY

WHERE?: SANTA BARBARA, CALIFORNIA
HOW?: BUS TRANSPORTATION FROM FEATURE
 ANIMATION BUILDING
WHY?: TO NAIL DOWN CHARACTER DESIGN
 AND HARNESS CHAOS

TRADITIONAL GREEK CUISINE
ALL NIGHT BAZOUKI DANCING AND ENTERTAINMENT
(PLEASE DO NOT THROW YOUR PLATES!!!)

ABOVE: HERC, ZEUS AND FRIENDS DANCE THE BAZOUKI.
ART BY ROWLAND WILSON.

Hades Blazing Tornado

Many of the characters—like Pegasus—were taken directly from my designs, almost exactly as I did them; others were adapted from my designs. For the overall effort of the animation team, I can't praise them enough.

But really, who am I to go and tell another artist how to draw? One does not just go and tell another artist what to do. I said to them at the time, "Listen, I'm not saying I draw better than you, or that I'm better than your style. It's just that the directors want it to look like my work." And they replied, "Oh, don't worry. We're used to being told what to do all the time." As Thomas Schumacher once told me, "It's simple when everyone is that talented. It's a conversation, not an argument."

Some of the animators did find this process very difficult, though, and reverted to Disney house style naturally.

There was a session with the animators where we all drew together for the first time. I felt nervous. Who was I to come to these experienced Disney animators and say, "This is the way we want it"? One artist, Sue C. Nichols, compiled boards of how to draw in the "Scarfe manner." I learned a lot from the experience about who I am and how I draw. For instance, I apparently take the line and I reverse it. I didn't know I was doing that. I don't usually think about my style. When people ask where I get my artistic style, I always say that it's like handwriting. It just comes to me.

The animators then took my drawings to study and began to start on them—while I returned to London and continued working from there. Drawings from the animators would arrive regularly by mail, and I would correct and adapt them. Then I would fax my versions back to them with handwritten tips and suggestions. At first, the animators found it difficult to adapt to my style, finding it hard to make sense of my drawings in a three-dimensional way. They tended to see them as graphic, flat, two-dimensional. When I drew a round belly, they couldn't see it as round. They just saw a circle. In my mind, when I'm drawing that round line, it's full of flesh and innards. As I'm drawing, I'm imagining a complete, 3D figure. Some of the animators were able to see this, while there were others who couldn't. The different reactions were quite interesting.

Every now and then I would fly back to Los Angeles to check in on things, and when I saw the first animatics, it was very exciting. It was like, here is something that's come out of my mind onto the paper and gone through a production process, and now it's walking about and expressing emotions and talking. I had done animation before, but never quite of this ilk. This was top stuff!

"Andy Gaskill, the film's art director, described Gerald's work as 'exploding off the page.' Gerald's concept drawings were so inspiring that they pushed the development work to the extreme. When the work came back toward a more traditional Disney look, it was still very stylized. His work is so bold and imaginative it gave us energy."

—Thomas Cardone, artistic supervisor for backgrounds (from *The Art of Hercules: The Chaos of Creation*, Hyperion, 1997)

Above: Phil dances with glee as he shows off the Hercules banner.
Opposite: An early drawing of Hades, when I was convinced he should be made of smoke and fire.

The Scarfian Style

I'm told that the neo-Grecian Scarfian style worked for this film, but looking back, I would have liked to have had more influence over the overall style. But, of course, it was such a huge project, and I always had to listen to other people's views. I was invited to intervene at every point, but it was hard to have any impact once the whole thing started to solidify.

But that's what happens on a film. We know that all the stories are reworked to a point where we're never quite sure what the original intentions were. Most theatrical productions are also interpretations of the source material. I read the script, of course, but not in a very detailed way. I'm not one of those people who studies things in detail—even when I designed the opera *The Magic Flute*, for example, I didn't study the score in depth. But I knew the music and that was enough to inspire me; I knew what I wanted to create. Of course, my work is often influenced by the task at hand . . . but I often just kind of go my own way because if you present something to the directors, they might accept it even if it isn't what they wanted initially. That's part of my job, to trigger thoughts and designs all the way through production.

I was never quite sure, when I began to design the characters for *Hercules,* whether Disney wanted the film to be comical or to have some of my darkness in it. I think we eventually produced something that contained both elements: a little dark comedy of sorts.

The schedule for the film was essentially "as soon as possible," and I was diligent about keeping to it, producing a huge amount of material on time. I have always been very fast and prolific in my work. Perhaps owing to my days as a political cartoonist, it's always up against a deadline and often involves producing material that wouldn't exist without one. I utilized the energy that a deadline produces, and, in Disney's case, I used it to make as many variations and options on each theme as I could.

One of the instructions artist Sue Nichols gave when asked for her advice about reproducing my drawings was, "Beware of line mileage." By which she meant that anything that you add to the drawing, however tiny, would add up to a lot of extra time—which is money in Hollywood. For instance, in cartoons, we often see characters who have only three or four fingers. That's because just cutting out those one or two fingers saves time and money. Mickey Mouse has only four fingers—now, that's being aware of line mileage.

"While trying to incorporate Gerald's style into my first drawings of Hades, I reviewed his early work on the film. I happened on a very cartoony version of Cerberus. I asked him, 'Where did this come from?' and he said, 'At the beginning, I wasn't sure how cartoony they wanted me to go.'"

—Nik Ranieri, supervising animator for Hades (from *The Art of Hercules: The Chaos of Creation,* Hyperion, 1997)

These pages: Three joke drawings of Hades. In an effort to see what Ron and John wanted in the way of humor, I occasionally sent them light-hearted drawings amongst the darker images.

GERALD SCARFE

IS THE ARTIST THE DIRECTORS HAVE CHOSEN TO BE THE MAIN INFLUENCE ON OUR STYLE.

HIS STYLE IS NOTED FOR EXAGERATED CARICATURIZATIONS OF PERSONALITIES, ATTITUDES + ACTIONS.

AN ENERGETIC, SWEEPING LINE PUSHES HIS CARICATURE ~ OFTEN DISTORTING TECHNICAL ANATOMY + PERSPECTIVE IN ORDER TO EXPRESS HIS POINT CLEARLY.

HERE ANATOMY GIVES WAY TO FLOW OF ACTION

HERE TECHNICAL FORM GIVES WAY TO PERSONALITY, ATTITUDE

FORM IS SECONDARY TO ATTITUDE
• ATTITUDE OF CHARACTER
• ATTITUDE OF ACTION

MIXIN' GREEK -N- SCARFE

BOLD SHAPES FOR BASE

ELEGANT DETAILS ADDED

VIA REPETITION OF LINE

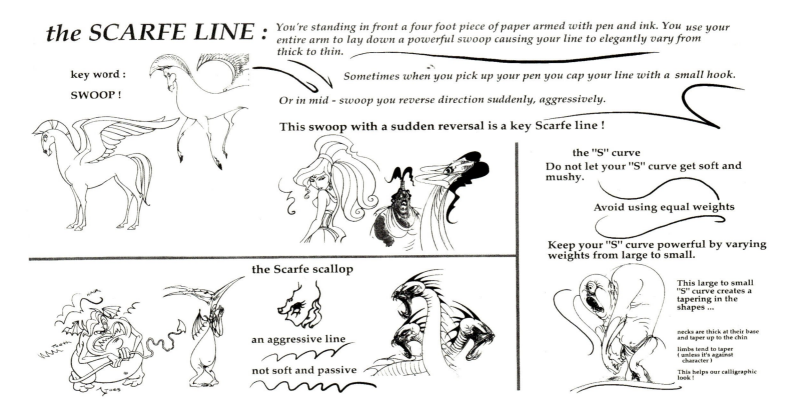

the SCARFE LINE :

key word :
SWOOP !

You're standing in front a four foot piece of paper armed with pen and ink. You use your entire arm to lay down a powerful swoop causing your line to elegantly vary from thick to thin.

Sometimes when you pick up your pen you cap your line with a small hook.

Or in mid - swoop you reverse direction suddenly, aggressively.

This swoop with a sudden reversal is a key Scarfe line !

the "S" curve
Do not let your "S" curve get soft and mushy.

Avoid using equal weights

Keep your "S" curve powerful by varying weights from large to small.

the Scarfe scallop

an aggressive line

not soft and passive

This large to small "S" curve creates a tapering in the shapes ...

necks are thick at their base and taper up to the chin

limbs tend to taper (unless it's against character)

This helps our calligraphic look !

"Technically it would be impossible to 'do' Gerald's style because of all the lines, scallops, and points he uses that make everything harsh. For [the] villains, the Hydra, the Fates, Gerald's 'baddies,' you can use them as is; for your lead characters, cute little Hercules babies, people with whom you have to empathize, it can be too threatening.

He found what the directors liked about his work was the caricature of character. The bizarre, stretched shapes, the long pointed noses. The trick was in saying, 'How do you take Andreas's Hercules and make it feel like Gerald?' It's in the exaggeration of movement in animation that all of the sudden, it starts looking more like Gerald."

—Sue Nichols, production stylist (from *The Art of Hercules: The Chaos of Creation*, Hyperion, 1997)

Sue Nichols' clever diagnosis of my style. These charts were issued to all the relevant animators to have instant reference to my style. I enjoyed reading these and learnt a lot about myself. I didn't know for instance that in mid-swoop of my line I reverse direction suddenly and aggressively.

I admired Sue because, although she believed in her heart that my style would not work for Disney, she knew that the directors wanted it in the production, and therefore, she persevered in explaining it to the animators in order to make it work.

> "My approach to these very brilliant animators was simply, 'Listen, I am not saying that my way is the best. It's just my way, I'm only trying to help you.' The animators, who couldn't have been more gracious, kept saying, 'Don't apologize. We're used to having our work criticized.' It was like doing surgery, with animators coming in with their drawings, and I, like a doctor, saying, 'Do you need the legs this long? The nose so short?'" —Gerald Scarfe

Enormous Admiration

Overall, the animators made the whole process of creating this film extremely easy. And Sue Nichols—although she freely admits in the book *The Art of Hercules: The Chaos of Creation* (Hyperion, 1997) that she didn't think my character designs would work on screen—did her very best to make it work . . . and she achieved it! I have nothing but thanks for her direct feedback and appreciation for what she did.

I grew to admire enormously the Disney artists working with me on *Hercules*. They could do anything with a pencil, producing in just a few drawings physical expressions of unrequited love, jealousy, or anger—not just the obvious emotions, but the subtlest things, too. This is helped, of course, by the voice actor. When they record the script, they are filmed, and their expressions, gestures, and eye movements can be picked up by these clever animators—later added to their drawings to produce visual expression of their emotions.

Disney characters always had a specific, adorable look to them, but I know now that these artists are able to do anything. These animators are brilliant, and looking at their drawings of characters like Hercules, Hades, and Meg—they're like real people. They're drawings, but they have the feeling of being alive.

In the later days of the production, I found myself being influenced by the Disney style, too—it had crept in without my realizing. All those months going over and cleaning up the animators' drawings had rubbed off on me. I was beginning to lose out. I was starting to become . . . Disney-fied.

Overall, in the film I didn't do too bad, but I didn't achieve a hundred percent of what I would like to have done. But I'm very happy with it and very flattered that they asked me to help on this film. No question about that.

Throughout the process, there were those who didn't see me as any kind of threat, and there were others who couldn't adapt to my style and felt uneasy. There were some—like Chris Bailey, the artist who drew the centaur, Nessus—who were on to it straight away. I initially designed the character as a Hell's Angel biker type. I often have an image like that in my mind when I'm drawing specific characters; I have a kind of feeling of what they should be. And Chris got it immediately. In fact, his version of Nessus is more beefed up than mine was—my original designs were a bit too elegant, perhaps. Whereas for Pain and Panic, the animators found

I occasionally sent appalling jokes to the directors.

it really tricky. But they were all really trying, and that's what I liked. I never felt they were thinking, "Oh, God, it's him again."

When the animators endeavored to copy my drawings—or what they thought was my style—I would go over their drawings with my own pencil. That was the only way I could teach them. I'd have to try to maintain a clean line with a sweet sweep to it. The shapes could turn out ugly within those lines, unless I corrected it, which was my job.

Chris took my drawing (above), and added much stronger limbs to the horse part (right). Improving him immediately by giving him stout, heavily muscled legs and body.

"In the Disney film, Hades is sharp-tongued and quick-witted, thanks to the voice talents of James Woods. He's more sarcastic than aloof, but he becomes terrifying when enraged, as scorching flames erupt from his head and limbs." —Gerald Scarfe

November 17 1995

Dear John, Ron and Alice

Still suffering from the dreaded 'flu, but couldn't resist sending back these variations on Hades. Rebecca says that he is now based on James Woods and kindly sent me some photographs, and I have been studying these and trying to adopt some of his features without doing a direct caricature of him.

I think his lips and eyes are very distinctive and I have used them together with his rather pronounced cheek bones. I hope they prove useful to Nik.

I enclose a letter to Rebecca, because I would dearly like to see what progress has been made on the Burnt Man, the Earthquake Lady, the Heavy Set Lady, etc etc. and I'm wondering if she can send me some updates.

More to come next week,

Best wishes

I loved doing this in a way because it tidied everything up in my art. The Disney animators tried very hard to get the feel of my work, but there was no way they could use my lines, which were not necessarily precise. (In some cases, it may appear as though I've done two or three lines when one would've sufficed. I tried hard in the beginning to make these designs single-line drawings.)

The commercial studio I worked for when I was young taught me how to draw "properly." In other words, reproducing an item on paper that you could clearly recognize—although because it was a studio producing commercial catalogues, I had to glam it up and make it look enticing.

Opposite: (Top) The marvellous James Woods, whose voice brought Hades to life: His sardonic, sarcastic style turns out to be perfect for the wicked god. The voice has to be recorded before the animators can draw the lip sync to it. Unfortunately, to my regret, I have never met James. (Bottom Right) A quick note to Nik Ranieri, the supervising animator of Hades.

Top and Left: Cleaning Up Poseidon and Pegasus: Two examples of how I directed the major animators in cleaning up, giving my line, and refining the shapes of all the characters.

SCARFISMS – Renowned British artist/political cartoonist Gerald Scarfe (The London Sunday Times, "Pink Floyd—The Wall") was a major influence on the overall look and character design of "Hercules" in his role as production designer. The talented artist helped to make this film one of Disney's most striking and unusual looking animated offerings, with a style all its own that perfectly fit with the filmmakers' comedic approach to the subject. "Hercules" is Walt Disney Pictures' 35th full-length animated feature.
HERC-30

photo credit: GARY KRUEGER

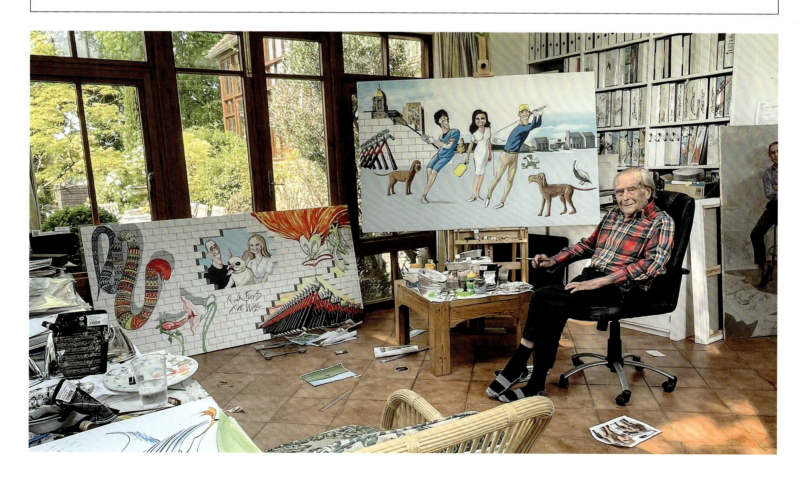

A lot of my instruction to the Disney artists was about getting the physical structure of the characters right. Even though they were cartoons, they still had to have a 3D sense to them. A lot of the artists were drawing bodies that couldn't exist in three dimensions: Limbs were badly drawn or in the wrong place, for example. All those technical skills were essential to what we were doing with the characters in *Hercules*.

Ultimately, toward the end of working on the film, I was cleaning up some drawings and trying to give the Disney images my artistic style and feel, but they were, without a doubt, Disney images all the way through. Was I becoming a Disney artist myself? Well . . . There were 900 of them and one of me.

I want to thank all involved: the directors, the artists, the whole crew. I had a great time.

"I think the Disney effect began to affect me, too. There were about nine hundred of them and one of me, so you can guess who won out. But ultimately, although I flatter myself, I did have an effect on the movie as well."—Gerald Scarfe

Opposite top: Publicity still of Hades and me for the Press.

Opposite below:: Me in my studio today, with two oil paintings commissioned in America.

Left: This is one of my favorite drawings. It was my effort to show the animators how the character would be animated, and what positions it would take when falling downstairs, tumbling, and bouncing from step to step. I like seeing the forms the figure would take in my particular style. A taller, slimmer figure would fall like a bundle of sticks, all angles and uncontrolled whirling of limbs as it clattered downstairs. This is an earlier take on Thalia, and she ended up being much more graceful than this.

The Legend of Hercules

"Long ago, in the faraway land of ancient Greece, there was a golden age of powerful gods and extraordinary heroes. And the greatest and strongest of all these heroes was the mighty Hercules. But what is the measure of the true hero?"

THE VERY FIRST LINES UTTERED IN Disney's *Hercules* set the viewer up for an adventurous tale of one of Greek mythology's most iconic heroes, and that is where we shall begin as well.

In the Disney classic, soon after his birth, Hercules—the infant son of Greek gods Zeus and Hera—is ripped from his home atop Mount Olympus and cast into the world of mortals below, thanks to the machinations of Hades, lord of the underworld, and his minions. After ingesting a powerful potion, young Hercules is almost fully stripped of his godhood, retaining only his superhuman strength.

Under the guidance of his adopted mortal parents and a gruff satyr named Phil, Hercules must navigate his awkward adolescent years and go from "zero to hero" if he ever hopes to make his way back to Mount Olympus and rejoin his true family.

The story surrounding the Disney animated film would deviate from the Greek legend of Hercules in many ways, but it would ultimately start with Zeus and Hera, and that is where I began, seeking inspiration at the British Museum (page 34).

The real mythologies behind Hercules's tragic upbringing and adulthood inspired many of my early sketches and character designs, as you will see in the following pages.

Opposite: Slaying the Stymphalian birds.

Above: Statue of Hercules fighting the centaur Nessus, Florence Italy.

The Twelve Labors of Hercules

In the original Greek legend, after Hercules tragically murdered his wife and sons in a blind rage—in response to Hera's insistence that he had gone mad—Hercules was desperate to atone for his sins. Considering ending his life, he pleaded with the god Apollo, who consulted his Oracle at Delphi. He was told to complete twelve challenges (or labors), and only then would he be able to atone for the murder of his wife and children and live in peace. The story goes that Eurystheus, who gave Hercules the twelve labors, was slightly scared of Herc, and hid from him in a large olive jar when Herc was around. Bizarre!

Some of the twelve labors that inspired my designs were the Cretan bull, the Death of the Minotaur, Medusa, and the dreaded nine-headed Hydra.

Opposite: The massive Minotaur.

This page: Hercules and the Cretan Bull. The Cretan Bull was the father of the Minotaur. Hercules captured the bull on his own, and showed it to Eurystheus, who had given him the task, as he had with all the other tasks. I guess Eurystheus peered out of his jar and said 'Fine', and Herc let the bull go.

HERCULES TAUNTS THE MINOTAUR

DEATH OF THE MINOTAUR

HERO SIDESTEPS WITH HIS CAPE & THE MINOTAUR FALLS HIS DEATH

The Characters Come to Life

IN THE FOLLOWING PAGES YOU will see my attempts to arrive at the final characters for the film: my interactions with the animators through notes, faxes, and visits to L.A. Finally, you will see the characters as they appear in the film.

We start with the Muses, as the film opens, and then we will visit our favorite heroes, villains, gods, goddesses, and so much more.

Opposite: The monstrous, one-eyed Cyclops looks over the ruined city of Thebes.

Above: Arms flailing, Pain plunges through the skies.

Left: A satyr out and about looking for trouble.

THE MUSES

In the Disney film, the Muses sing the narrative that spans throughout the story. And, to open the film, they sing a lively Disney musical number. They are essentially the gospel group, narrating the story as we go.

In Greek myths, each Muse has their own characteristics. I knew what their personalities should be: One was theatrical, one was dance, and so on. I did my research, but then, of course, being a fantasy and being a Disney film, the characters don't have to be exact.

CALLIOPE
MUSE OF POETRY

THALIA
MUSE OF COMEDY

TERPSICHORE

THALIA

"*We are the muses, goddesses of the arts and proclaimers of heroes.*"
—Calliope, *Hercules*

"*Heroes like Hercules.*"—Terpsichore, *Hercules*

"*Honey, you mean 'Hunk-ules.'*"—Thalia, *Hercules*

MELPOMENE

MUSE OF TRAGEDY

TERPSICHORE
MUSE OF DANCE

CLIO
MUSE OF HISTORY

HERCULES

Demigod, son of Zeus

Hercules is the main protagonist in the classic Disney film—the son of Zeus and a demigod celebrated across Greece for centuries. Born with superhuman strength, he's able to persevere through any challenges thrown at him.

Wrestling with Hercules was my first task: What did he look like? I knew he had to be handsome and strong; he was a hero, after all. But how could I convey that in a drawing? I had studied the Greek myth and was a longtime fan of archaic Greek statues. That was a start.

This illustration was my first attempt. Far too realistic, I thought. Herc needed to be more of a cartoon, but I knew this was not the answer. I had to try different approaches.

HERCULES

Hercules + the Giant Crab

Previous page: Hercules stalked the Nemean Lion and shot at him with his arrows, not realizing that the lion's golden fur was impenetrable and the arrows glanced off. So Herc followed the beast to its cave and stunned it with his club; then, using his immense strength, he wrestled with it and strangled the lion to death. Using one of the animal's own claws, he skinned it and donned the pelt. Attaboy Herc.

Above: Slaying Carcinus, the giant crab that guards the Hydra.

Opposite: Capturing the Erymanthian boar.

Aercules & The Giant Boar

Here:
Too old!
But am sending
for Phil

Further exploration of Hercules,
and also Phil, their size and
relationship.

Above: Hercules wrestles with Death and shows him his own image in a mirror to defeat him.

Next spread: The Stymphalion Birds scatter as Hercules rides the skies on Pegasus. I've made Hercules's head far too small in this drawing.

"His work is aggressive. It's uncluttered, has a smooth elegance, and his shapes guide the eye. Of the reproduction work that had already been done on Hercules's character by Sue Nichols, Andy Gaskill, and Gerald, all of which look completely different, Gerald's gave me the most confusing signals of all."

—Andreas Deja, supervising animator for the character Hercules (from *The Art of Hercules: Chaos of Creation*, Hyperion 1997)

Hercules wearing the golden pelt of the Nemean Lion he slew. I tried various styles of drawing in order to inspire different ways of depicting the characters.

Above: Hercules and Death.

Left: The Hydra dwelt in a swamp near Lake Lerna. A giant crab came to assist the Hydra, but Herc slew the crab. He found the Hydra more difficult, however, as when he cut one head off, another one or two would grow in its place. Herc called upon his nephew, Iolaus, to burn the stumps with a flaming torch and stop them coming back. He then dipped his arrows in the poisonous blood, and later used them to kill the Centaur, Nessus.

Hercules and the Hydra

HERCULES
1461
HERCULES
Clean up model sheet
Date 12/19/95
OK √ JM _____ RC _RC_

THIS MATERIAL IS THE
PROPERTY OF
THE WALT DISNEY COMPANY

IT IS UNPUBLISHED AND
MUST NOT BE TAKEN
FROM THE STUDIO, DUPLICATED
OR USED IN ANY MANNER
EXCEPTING FOR PRODUCTION
PURPOSES, WITHOUT WRITTEN
PERMISSION FROM AN AUTHORIZED
OFFICER OF THE COMPANY

HERCVLES

"I struggled with Hercules. I still like the end
result of the character design, although it is
very reminiscent of a classic Disney hero."

—Gerald Scarfe

Top: The directors approve the Hercules design,
signing off on this model sheet.

Right: A determined Hercules.

Opposite: Andreas and I sat and drew together
to discuss the look of Hercules (top), sketching
our ideas on paper. My drawing is in the center.
Andreas knew exactly what he was doing, having
drawn many Disney characters before. Sue
Nichols's guide to my Hercules (below), trying to
keep everyone in line.

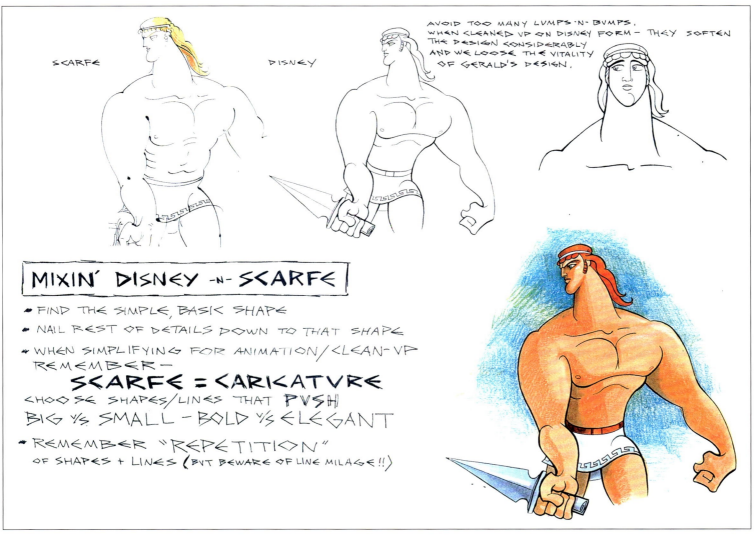

AVOID TOO MANY LUMPS·N·BUMPS.
WHEN CLEANED UP ON DISNEY FORM — THEY SOFTEN
THE DESIGN CONSIDERABLY
AND WE LOOSE THE VITALITY
OF GERALD'S DESIGN.

SCARFE

DISNEY

MIXIN' DISNEY -N- SCARFE

- FIND THE SIMPLE, BASIC SHAPE
- NAIL REST OF DETAILS DOWN TO THAT SHAPE
- WHEN SIMPLIFYING FOR ANIMATION/CLEAN-UP
 REMEMBER —
 ### SCARFE = CARICATURE
 CHOOSE SHAPES/LINES THAT PUSH
 BIG ⅛ SMALL — BOLD ⅛ ELEGANT
- REMEMBER "REPETITION"
 OF SHAPES + LINES (BUT BEWARE OF LINE MILAGE!!)

"You almost know when a character arrives. Various characters come in and audition on your drawing board, but they don't look right. Suddenly, one arrives and you think, 'That's him, that's the guy!' And you almost say to him, 'I've been waiting for you. Where have you been?' Hercules was the most difficult . . . the good-looking ones always are. In fact, Hercules is such a very handsome hero that with him, I could just suggest this rather hugely masculine figure, who's not the cleverest guy in the world."

—Gerald Scarfe

YOUNG HERCULES

He had the best tutors, learning fencing, archery, horse riding, and so on, but was pretty clumsy and ungainly, with a tendency to break things. However, all who knew him were astounded by his enormous strength.

I KNOW I'VE SAID IT BEFORE AND IT'S PROBABLY TOO LATE NOW AND AT THE RISK OF OFFENDING THE BRILLIANT RANDY — I STILL THINK THE HANDS, CALF MUSCLES AND FEET ARE TOO LARGE — EVEN ALLOWING FOR HIS PUPPISH, GANGLING CHARACTER

G.

Regarding accident-prone teenage Hercules, I had a back-and-forth with Randy Haycock, animator of Young Hercules, about bulbous calves and enormous hands. Randy said that at that age, when he was young and gangly, he was clumsy, and he was just trying to capture that. I argued, but lost the battle and his young Hercules made it into the final movie You win some . . .

> *"I am a freak. I try to fit in. I really do. I just can't."*
> —Young Hercules, *Hercules*

Dear Randy

I've only had time to go over young Herc very quickly. As I mentioned in Santa Barbara I felt his feet were too large, so I have gone over them making them smaller, and also taken out the slightly bulbous quality of the legs. I think perhaps I have made the feet <u>too</u> small - it's a matter of degree. I hope to include in my next package more drawings for you, but in the meantime if there's anything I can do don't hesitate to contact me by phone or fax. It was good to meet you.

Best wishes

ZEUS

King of the Gods

The almighty Zeus, king of the gods, Mr. "Hey You, Get Off of My Cloud," was a treat to design.

Full of imperious gravitas, he ruled the heavens. The big boss on Mount Olympus, known for his penchant for wooing the ladies and for hurling his thunderbolts.

I've always thought of Zeus as made of something extremely solid, very angular. I studied the statues at the British Museum and sat for hours in my studio in London, pouring over every Greek art book I could buy. I'd sent drawings of a simple shape of Zeus's head, based on the Greek sculpture I had in mind.

This page: Early pencil sketch of Zeus, the mighty father of the gods.

Following pages: Zeus, in the clouds high above Olympus, fights off the Stymphalian birds with a bolt of lightning. I made these drawings of Hercules and Pegasus in the Temple of Zeus because I wanted to show the might of this all-powerful god. I wasn't sure which way the film would go, but I felt drawings like these might influence the eventual animator to give Zeus gravitas.

Zeus Rides the Clouds

Turbulent Clouds -
flow - like speeded up
film of real clouds -

ZEUS KIT. BY ETHEREAL SHAFTS OF LIGHT
TEMPLE OF ZEUS

Zeus + Pegasus

This spread: Various attempts to arrive at a design. I was pretty close from the start, although this version of the stern father of the gods turned out to be much more friendly and avuncular in the film, voiced by the wonderful Rip Torn.

Zeus

"One thing that's important to the animation print process is not having too much pride. Everything doesn't have to be your own idea, because the ultimate goal is just to make the best film you can make. It's funny about Gerald's work—you look at it superficially and it doesn't seem adaptable to three dimensions. But once you start analyzing his shapes, once he starts explaining things to you, you realize that he does think three-dimensionally. I never felt pushed by him or the directors to do something I didn't want to do. Gerald's approach in showing us his drawings was more sort of 'This is what I did, and maybe you can adapt my ideas to your animation.' And since usually his ideas are pretty good, they're worth using. He'd done a drawing of Zeus's head which had a triangular, cowcatcher kind of beard that swoops down. I thought I had the design working when my fellow animators pointed out that I was drawing the beard kind of bushy."

—Anthony de Rosa, supervising animator for Hera and Zeus (from *The Art of Hercules: The Chaos of Creation*, Hyperion, 1997)

"Once I started drawing the head and beard more closely to Gerald's concept, it didn't change things tremendously, but completely solidified the design. His influence is everywhere."

—Anthony de Rosa, supervising animator for Hera and Zeus (from *The Art of Hercules: The Chaos of Creation*, Hyperion, 1997)

Top: Series of drawings to show how Zeus is formed in simple terms for the animator Tony, who couldn't seem to see my drawing in three-dimensional terms. He said my drawing of Zeus had a "cowcatcher beard." I hadn't seen it that way, but recognized what he meant: It looks a bit like the cowcatchers on the front of early locomotives—you learn something all the time.

Above: Tony's wonderful drawing for me.

Right: According to Greek mythology, Hades was the brother of Zeus and Poseidon. After the kingdom of the gods was divided, Hades was given the underworld—whereas Zeus received the heavens and Poseidon, the sea. Hades ruled the underworld with his queen, Persephone, sometimes aided by his three-headed dog, Cerberus (page 202). Hades was never the judge or jury, but he reigned as a forbidding and aloof god.

Opposite above: A preliminary sketch for a motherly Hera by her animator, Anthony de Rosa.

"*Uh, powerful little tyke.*"

—Hades, *Hercules*

HERA

Queen of the Gods

Everyone feared the wrath of Hera, queen of all the gods.

Hera was often portrayed as the jealous and vindictive wife of Zeus (who was also her brother—don't ask!). She had her reasons; he was a serial philanderer. Zeus's trick was to "visit" young ladies in disguise—sometimes in the form of their husbands, so they would let their guard down.

In the Disney film, Hera is portrayed as a sweet, kind, beautiful, gracious, and motherly woman.

OLYMPUS

Opposite: In early days I thought at one point that Hera might be the equivalent of a Hollywood or Beverly Hills society queen, and I would set Olympus in the Hollywood Hills, but the directors, Ron and John, didn't go for that interpretation.

This page: The final Hera arrived, and Peter Schneider, former president of Walt Disney Animation Studios, said 'that's her! No doubt'. Also Ron and John immediately approved the design. Some characters come easily.

"I imagined Pegasus as a beautiful, elegant creature. A horse for the gods, swooping through the sky in and out of the wispy, white clouds, joyfully, performing arabesques and somersaults high above Olympus."—Gerald Scarfe

This page: To help the animator of Pegasus: a series of drawings showing how this beautiful, elegant horse would come in for touchdown and land gracefully in style.

PEGASUS TOUCHDOWN

PEGASUS

Hercules's Winged Steed

Pegasus, I love. I was very intent that Pegasus wouldn't become the usual old dobbin, clip-clopping along.

I bought a resin model of the famous horse from the Acropolis, which I had in my studio to inspire me with its beautiful elegance. I wanted this elegant horse of the gods—not the old farmyard, dear old thing—which it did begin to become. Supervising animator Ellen Woodbury began to tip toward that, and I had to send her faxes saying, "He's getting a bit comic." But I realized it was her job to make it not only elegant, but comic—a funny character as well. Once again, he's not the brightest character, but we love him all the same.

FOLIES BERGÉRE FEATHERS

LONGER LEGS

CLEAN UP – KEEP AN ELEGANT FLOW TO THE LINE
G.

Left: In order to waylay Pegasus, Pain and Panic turn themselves into a beautiful female companion. Pegasus is clearly impressed.

Opposite: An early design of Pegasus on black paper, rising through a shaft of ethereal light, whilst Hercules looks on.

THE FULLY GROWN PEGASUS DECENDS THROUGH THE NIGHT

Ellen Woodbury was the supervising animator of Pegasus. As Ellen started to animate, I began to see that Peg had to be not only an elegant horse, but a horse with character. He had to be beautiful to look at but also display characteristics particular to him. It was decided that he was a "goofball," not terribly bright, and a figure of fun.

The Disney requirement of being fun to watch, and to laugh at, raised a question: Could elegance and comedy work together? Of course they could! If you think of an arrogant, elegantly dressed man falling face down into a puddle, it is all the funnier because he is high and mighty.

I found I was gradually being drawn into the Disney of style. In my faxes, I was correcting a Disney image. However, Ellen was very aware of my concerns, and Peg, as he appeared in the film, looked great and worked wonderfully. I was pleased.

THESE DRAWINGS HAVE GREAT VERVE AND FUN. I ONLY WONDER IF PEGASUS IS GETTING A LITTLE HEAVY AND LOSING HIS ELEGANCE. G.

HERCULES
PEGASUS
Clean up model sheet

HERCULES

To Gerald,
with many thanks.
Ellen Woodbury
5/10/97

"I look at Gerald's interpretations of Pegasus and of photographs of horse statues the team shot in Greece and now I think, 'Why couldn't I have looked at that and said, "Oh, that's my character"? But, no, you first have to struggle through this gray, unknown place where you don't know where you're going. Pegasus is a princely, refined, aristocratic goofball.'"

—Ellen Woodbury, supervising animator for Pegasus (from *The Art of Hercules: The Chaos of Creation*, Hyperion 1997)

Opposite: (Top) Attempting to get some humor into Pegasus and (below) a fax to Ellen.

This page: (Above) A drawing to show structure, (right) a lovely drawing by Ellen for me and (above right) Disney's approved model sheet.

"I was most insistent that Pegasus didn't become a funny old farm horse. Ellen naturally wanted to make him a comic character as well. But, I said, 'Even noble people can be comical.' Pegasus is elegant but stupid, like one of the grand, amazingly costumed 18th century figures who are all the more funny when they fall into a puddle."

—Gerald Scarfe

How I first drew the elegant Pegasus.

I LIKE TROJAN HORSE MANE

PHILOCTETES (PHIL)

Hero and Mentor of Hercules

Philoctetes is a satyr—a being that is half-human and half-goat.

Phil, as he likes to be called, is a stocky, explosive goat man, wonderfully voiced by the great Danny DeVito. Another favorite character of mine, Phil was Hercules's mentor and trainer throughout the Disney film, getting Hercules ready for his many adventures and battles, while providing support and friendship along the way.

"*Two words:
I am retired.*"

—Phil, *Hercules*

"Phil—you can't help loving him."
—Gerald Scarfe

Nymph

This spread: Three early experimental designs for the pugnacious Phil

I saw him as a punchy, pugilistic
little goat man, spoiling for a fight.
He's aggressive and, although sometimes
exasperated by Hercules, he is always
fiercely protective of him. Herc is his boy.

PHIL IN TROUBLE

"I trained all those would-be heroes. Odysseus, Perseus, Theseus. A lot of 'yeuseus.' And every single one of those bums let me down flatter than a discus."

—Phil, *Hercules*

Left: Phil rides Pegasus through the Olympian skies.

Opposite above: My drawing of Phil's "man cave" where he keeps all his precious training equipment.

Opposite below: Phil model sheet approved by the directors.

"People look at the characters in Disney features and shorts from the 1930s and 1940s and say, 'They were so complex, so detailed.' If you really look at the character design in, say, Dumbo (1941), the characters are very streamlined, very simple to draw, very graphic. It was their movement that made them three-dimensional. On Hercules, Gerald's style is also very curvy and graphic. Oddly enough, it's not that far afield from Fred Moore's Mickey Mouse— in other words, an appealing, expressive kind of drawing that this company cracked sixty years ago. Phil isn't a million miles removed from Grumpy [Snow White and the Seven Dwarfs], either; they're both little curmudgeons. In terms of shape designing, Phil still has the qualities of a Scarfe drawing, but it has a little more form to it. I really like Gerald's slightly gnarly way of drawing hands. I use that for whenever Phil is frustrated."

—Eric Goldberg, supervising animator for Philoctetes (from *The Art of Hercules: The Chaos of Creation*, Hyperion, 1997)

THIS MATERIAL IS THE
PROPERTY OF
THE WALT DISNEY COMPANY

IT IS UNPUBLISHED AND
MUST NOT BE TAKEN
FROM THE STUDIO, DUPLICATED
OR USED IN ANY MANNER
EXCEPTING FOR PRODUCTION
PURPOSES, WITHOUT WRITTEN
PERMISSION FROM AN AUTHORIZED
OFFICER OF THE COMPANY

HERCULES
1461
PHIL
Clean up model sheet
Date 10/20/95
OK √ JM RC

PAGE 1 OF 3

HERCULES

HEY, GERALD! THANKS FOR FULFILLIN' OUR ARTISTIC HUNGER !!

Top: Danny DeVito recording Phil in the studio.

Right: Eric's drawing for me, framed and hanging in a place of honor at my home.

"When I heard that he was to be voiced by Danny DeVito, my vision of Phil became crystal clear. He was Danny DeVito."—Gerald Scarfe

Left: A drawing I made of Danny in the *New Yorker*, Dec. 27, 1999.

MEGARA (MEG)

Wife of Hercules

Meg, a very Disney heroine. My early drawings of her were much more Grecian.

When we meet Meg, she's being harassed by Nessus (Page 124). Hercules steps in on her behalf to save her and defeats the salty creature. Much to Meg's surprise, she ends up falling in love with our clumsy but well-meaning hero.

I'm not terribly good at illustrating women. Whenever I'm asked to draw a caricature or portrait of a woman, I'm always a little bit wary because my mum told me to be polite. Times have changed, but I tend to still hold doors open, which is not done these days. I'm not old-fashioned, but I do have difficulty with caricaturing women and making them look too extreme.

Meg, as a character, is quite dark, too. She has her moments, and she's sort of snarky. Disney heroines have evolved over the years.

This page: Meg I found really tricky. First, I based her on my British Museum research and made this strange—for me—set of watercolor sketches, which I don't like.

Opposite: I'm not great at drawing women (unless, of course, it's Mrs. Thatcher). Quite rightly, long gone are the days when Snow White would cook and sweep out the Seven Dwarfs' cottage. Today's Disney heroine is a different kind of woman. When Ken Duncan started to animate the character, he knew exactly how to tackle and animate a Disney heroine as a strong-willed, lively, independent young woman, so I began to follow his model, but adding my line in order to maintain consistency.

"*I'm a damsel.
I'm in distress.
I can handle this.
Have a nice day.*"

—Meg, *Hercules*

Top: A Meg model sheet.

Above: Herc confronts the dangerous Nessus.
He finally rescues Meg (film still).

Opposite top: A very early sketch of Meg and (below)
clumsy Herc and cross, drenched Meg from the film.

NEG — BUT TOO OLD —

"Aren't we forgetting one teensy-weensy, but ever so crucial little, tiny detail? I own you!"—Hades, *Hercules*

This is a great representation of Meg's relationship with Hades. Hades had control and 'owned' Meg, because in a previous occasion he had helped her out of trouble.

NESSUS

Centaur Baddie

In the Disney film, Nessus acts as the river guardian and is in the process of confronting Meg when Hercules swoops in to save the day—knocking the bully unconscious.

I depicted him as a as a very large blue Centaur, with black hair and fearsome teeth. As cunning as he may have been in the original myth, the Nessus in the film proves to be slightly dimmer-witted.

I love drawing horses. Nessus isn't any horse, though; in his case, I would need the torso and head to show the character's brutality. I immediately knew he had to be a Hell's Angel type: unshaven with long, lank, straggly, greasy hair flowing over his neck and shoulders, and continuing down his mane to his twisted, tangled tail. A snarling, bitter, twisted, foul mouth with rotting teeth, and no doubt halitosis (can animators draw halitosis?). Not someone you would like to meet on a bright, sunny day, let alone a dark night in Thebes. Altogether a thoroughly bad lot: I love him.

"I immediately
knew he had
to be a Hell's
Angel type."
—Gerald Scarfe

Above: This was the head I wanted for my creation. As soon as I drew him, I knew this was our Nessus. As I've said, however many audition for the part, as soon as the correct character for the role arrives, I know. This was our beast, for sure.

Opposite top left: My final Nessus—exactly the Hell's Angel type I was looking for.

Opposite: Two powerful sketches of Nessus, showing how faithfully Chris stuck to my original design, and how Nessus appeared in the film.

This page: A couple of notes to Chris Bailey. He was definitely one of the animators who stuck very closely to my creation, as the great stills show.

Opposite: Chris's sketch (top) and (below) Nessus from the film—very close, as you can see, to my original design.

"I saw this Scarfe stuff which looked edgy, dark, fresh. His work has these long, violent, swooping lines punctuated by little, violent moments. It's almost like making a nice, swooping line and taking the pencil and jabbing the paper. It was inspirational to look at work of his where he wasn't tracing my drawing. I could see a little bit of inhibition on his part, as if he were trying to be accommodating to me as an animator."

—Chris Bailey, animator for Nessus (from *The Art of Hercules: The Chaos of Creation*, Hyperion, 1997)

HADES

God of the Underworld

There is a lot we can say about Hades, god of the underworld. Hades has always been my favorite, as I am very good at illustrating baddies. Be honest—we all love the villain. Maybe we shouldn't, but most people do.

We love their wickedness, and maybe that's because we know that in fairy tales, the villain will get his comeuppance in the end—but, of course, that never happens in real life. Maybe I shouldn't say it, but sometimes heroes can be a pain in the butt: dull as ditchwater, upstanding, and boring, simpering away about saving the heroine and the world . . . But of course I love the hero in our story, Hercules.

This page: I wanted to see what Hades would look like before I added his fiery hair.

Opposite: In this drawing on gray paper, I tried to design the environment of the underworld, with people imprisoned in glass-covered pits below the marble floor.

The character design of Hades sprung from my mind pretty much fully formed. Initially, I had the idea that he should be made of fire—the fire of the underworld, where he lived. Fire, fire, fire. I had done fire on other characters—the Wife from *Pink Floyd: The Wall* has flaming hair—but what he looked like, where he should come from . . . It's a mysterious process I go through. And I always find it very difficult to describe it, because a lot of it is osmosis.

When James Woods was cast, I started doing things differently. Not exactly caricatures, but the ambience of James Woods, really. And he turned into the sarcastic and witty Hades we see in the film. The Fates keep trying to tell him, "We foretell the future." And he's like, "Yeah, yeah, yeah, I get it." So he played it very much on that level. I did drawings to illustrate both visions of Hades—some very dark drawings of Hades and a few jokey ones.

Opposite: There are so many interpretations of Hades. Here, an imperious Caesar-like god, delivering his judgment on mortals from on high, a laurel wreath around his skull-like head.

I would let my pen wander over the paper, almost unconsciously, exploring various elements of the character, letting inspirational flashes do the work, allowing the character to assemble.

This page: And here an entirely different take on Hades. Ideas for him flowed constantly: I just enjoyed drawing him. Here he is sprouting bat wings.

Next page: (Left) I felt we should have constantly flowing molten lava as a dangerous and threatening landscape in the underworld and (right) Hercules chases Hades through the canyons of the Underworld.

"I researched some of the early drawings Scarfe had done for Hades, which ranged from the typical pitchfork-and-horns thing to the truly bizarre and twisted. You could tell he was exploring every possibility, trying to find out exactly what Ron and John wanted."

—Nik Ranieri, supervising animator for Hades (from *The Art of Hercules: The Chaos of Creation*, Hyperion, 1997)

Previous page: A very early concept design of Hades in his cavernous, fiery domain. An environment of dripping fire and brimstone, with a sea of bubbling, molten lava. Hades is seated on his winged devil throne, with dark glasses and horns. He greets us with a chilling 'Hi!'. An early but pretty accurate Pain awaits his commands.

This page: Smokey Hades. An amorphous, ever-flowing, winding, curling, and twisting plume of smoke like a will-o'-the-wisp.

This spread: Portraits of a brutal and cruel Hades, snarling and threatening—trying to find his character before I added the fire, which I knew would work and heighten the dramatic effect.

Next page: Hades, composed of smoke and brimstone, before I added his explosive fire.

Following pages: More early sketches of Hades.

Hades Cloak

"Hades has always been my favorite, I love illustrating baddies." —Gerald Scarfe

Opposite: Herc on Pegasus in pursuit of Hades's chariot, as it careens through the deep, gloomy dangerous canyons of the Underworld.

Top: I like the suggestion that he could have been a meteor and wanted the directors to see this design.

Right: Hades as flame itself: an ever-burning, raging fire, flickering and changing shape and intensity.

The final model for Hades. I had great fun drawing this villain. From the very beginning I conceived him as made of fire, always alive with a flickering blue flame—but bursting with explosive flame when he got angry. This worked out terrifically in the final film. I felt we should have constantly flowing molten lava as a dangerous and threatening landscape in the Underworld.

"I decided, because Hades lived in the underworld of fire and darkness, that he was the rather saturnine, sardonic creature capable of bursting into flame at any moment. He was almost the element of fire himself, able to rise from a smouldering ember into a blazing inferno. I always drew him with his hair of fire, with flames flickering along his fingertips. I'm drawn to Hades, it's human nature. Evil is always attractive."

—Gerald Scarfe

HERCULES HADES PAGE II
NOV -95

HERCULES
PROD. #1461
RUFF MODEL SHEET
DATE 11-6-95
APPROVAL

UPPER COSTUME IS LIKE
A TOGA NOT A TEASHIRT

NOT THIS

THIS

SKULL CLIP

WHEN CLOTH IS PINCHED,
JUST CONDENSE DESIGN

CLOTH WILL
PINCH AT
SHOULDERS

BACK

FRONT

THE BOTTOM
WILL TRAIL OFF
INTO SMOKE
(THIS WILL BE DONE
BY EFFECTS)

HE WILL
STILL
OF
COURSE
HAVE FLAMING
HAIR -

November 17 1995

Dear Rebecca

Thank you so much for your letter and package. I am faxing a set of drawings for Nik of Hades, based on James Woods.

It was great fun combining the two characters, and I hope that they are useful to Nik.

I would very much like to see what is happening to the characters that I have sent you that are being worked on - The Earthquake Lady, The Heavy Set Lady, The Burnt Guy etc. Any progress being made would be good to see.

I will be sending you drawings of The Crotchety Old Guy next week - I must say, sometimes this week I've felt rather like him.

Hope you're well,

Best wishes

HERCULES — HADES — NOV - 95

FIRE (HAIR) TO BE DONE BY EFFECTS

HERCULES
PROD. #1461
RUFF MODEL SHEET
DATE
APPROVAL

EYES ARE ROUND WITH BIG PUPILS

THIS

NOT THIS

EYEBROWS ARE JUST LINES, NO THICKNESS

DENTAL WORK CONSISTS OF MOSTLY GUMS AND PINCER TEETH

"Gerald,
Any help you can give us with the designs on these effects will be greatly appreciated. If you have any questions please don't hesitate to call. Thanks again.
Mauro Maressa

Above and top opposite: Keeping Hades on course: model sheets for Hades showing his clothing, head shapes, gestures, and expressions.

Left and below: Correspondence with Nik, the visual effects supervisor Mauro Maressa, and Rebecca Huntley, who steered my written comments to the right department amongst the animators.

Dear Nik

I really liked the drawings I saw just before I left Los Angeles. Hades seemed to have a real personality. I have made some more large drawings to show the full figure and to suggest variations on his head shape etc. I 've also been over your drawings of expressions and interpreted them in my style - they're very close to the direction in which you're going. I like the idea that Hades is a God impressive in his own way but landed with a bum job (we know he deserves it - but he doesn't) Maybe he leaves a trail of scorched fire wherever he treads? Or maybe he has flame thrower breath - although I have used that on one of the rock creatures. I hope all of this will be of help to you - please do not hesitate to contact me if you need anything. Do send me things from time to time so that I can see the way things are going, and if you need any quick answers there's always my fax. It was good to meet you.

Best wishes

"HADES"

TO GERALD-
THANKS FOR THE INSPIRATION!
- WE'LL DO LUNCH...

Above: Hades rides Nessus, while Pain and Panic hang on for dear life, drawn for *Hades: The Truth at Last*, Disney Press, 1997.

Right: An energetic preliminary sketch of Hades by Nik Ranieri.

Opposite: Two fabulous stills from the movie, showing angry Hades bursting into flames.

PAIN
& PANIC

Hades's Minions

Spirits of Pain, Suffering, and Fear

Pain and Panic, the sidekicks of Hades, denziens of the Underworld! Known for their whining and and anxious bumbling around, these two were great fun to imagine. The guy who played Pain was this character Bobcat Goldthwait, who I didn't know anything about. He has a very gravelly, painful voice. And so his voice was an inspiration for that design. I had drawn little devils before. A lot of it is partially baked. I also hearkened back to *Orpheus in the Underworld*, which is a jokey operetta about the gods on Olympus. So there are all sorts of influences that come in.

"I looked at Gerald Scarfe's work and thought, 'Cool!' It had a lot of flair, very disjointed, with most of the shapes being basic teardrops. I didn't see how it would translate to animation, though. How can we make a Disney movie with characters who disobey the laws of physics and anatomy? In fact, I figured the only practical purpose for Gerald's designs would be for inclusion in this book. But Ron and John were pushing for it, and it got to the point where I almost threw up my hands in the air and said, 'Guys, I give up. I cannot get this Gerald Scarfe thing to happen!'"

—James Lopez, supervising animator for Pain (from *The Art of Hercules: The Chaos of Creation*, Hyperion, 1997)

Previous page: Hades's sidekicks Pain and Panic in a cavernous underworld.

This page: My first attempts to find Pain.

Ongoing search for Pain, a little horned devil
with leathery wings and devil's tail.

Pain and Panic

When I heard Matt Frewers's voice, the grinding, screeching tone of it immediately helped me to visualize Pain's character. An anxious minion, continually at Hades's sarcastic and demanding beck and call. Pain and his cohort, the terrified Panic, had magic powers and could turn themselves into other objects and beings.

Panic. The name says it all: a timid, skittering, frightened little creature, shivering with tension.

DEAR GERALD –

TUANKS FOR THE LETTER AND THE DRAWINGS.
I'M SENDING YOU SOME OF MY DRAWINGS AND ANIMATION
SO YOU CAN SEE WHERE I'M AT. BASICALLY HERE'S HOW
I'M DRAWING PAIN:

- TRYING TO KEEP HIS HEAD
 BIG IN RELATION TO HIS BODY
- LONG SKINNY ARMS W/ BONY HANDS
- SHORT/STUBBY LEGS
- CROOKED OR SMOOTH TAIL?
- BITE TAKEN OUT OF HIS WING

DO YOU HAVE ANY COLOR SUGGESTIONS FOR PAIN & PANIC?

MOUTH SHAPES – I NEED TO GET AWAY FROM USING THIS MOUTH TOO MUCH

FOR DIALOGUE I NEED TO USE DIFFERENT MOUTH SHAPES
FOR EXAMPLE:

"WIDE OPEN" "E" "O" "U" "F"

ALSO I WANT TO SEE WHAT DIFFERENT ᶠᴬᶜᴵᴬᴸ EXPRESSIONS WE CAN GET OUT
OF PAIN LIKE: SURPRISE, CRYING, SAD, EXTREMELY FRIGHTENED.
I WANT TO MAKE EVERYTHING VERY BROAD. SO IF YOU COULD
HELP ME OUT WITH YOUR IDEAS I WOULD REALLY APPRECIATE IT.

THANKS –

James Lopez

PAIN #3

GERALD SCARFE VERSION

ANIMATION INTERPRETATION

HERCULES
PROD. #1461
RUFF MODEL SHEET
DATE 10-11-95
APPROVAL

Top left and opposite: Correspondence
with James Lopez in which I offered
information on how to draw Pain's shape in
simple terms, and he relayed his thoughts
to me.

Left: Model sheet for Pain.

Top right: Character art for Pain and Panic.

"The thing about Gerald Scarfe is his spontaneity. His work is almost improvisation with a pen. He gets up and draws where his feeling takes him. That's what I tried to do in the scene where Baby Hercules beats up Pain and Panic in their incarnation as snakes. I made them broader, more exaggerated than I normally would. Even for Herc, I made his hands really big because that made them more expressive."

—Randy Haycock, supervising animator for Baby and Young Hercules (from *The Art of Hercules: The Chaos of Creation*, Hyperion, 1997)

To Gerald,
It was a pleasure working with you!

Top: The final version.

Above: Drawn for *Hades: The Truth at Last*, Disney Press, 1997.

Right: James Lopez and Brian Ferguson were the supervising animators for, respectively, Pain and Panic. Here's a drawing Brian made for me.

THE FATES

"We know everything,"
"Past."
"Present."
"And future."
—The Fates, *Hercules*

In Disney's *Hercules*, the Fates are depicted as old women with extremely exaggerated features—snakes for hair, spiders in their noses, and an eyeball that they hilariously share.

These three spooky old crones, who foretell the future, were a joy to design. I dressed them in gowns, with monk-like cowls shading their lined and gnarled old faces. With their skeletal hands they would cut the threads of life using their sharp secateur-like scissors. Snip! And someone is gone.

My very first drawing of the Three Fates. Their supervising animator, Nancy Beiman, said she thought that my design of Clotho (on the left) was showing that she had only one eye. In fact, I intended her to have two eyes, but in my drawing her cowl was hiding her left eye. Thereafter, Clotho had one eye, and we were all happy with it. After some quips about their ability to see all (even that Hades was going to be late to their meeting), they hesitantly give Hades the prophecy of the mighty Hercules—catapulting the lord of the underworld into a revenge plot to rule all.

Clotho

Final Disney design for the Fates.

"All of us egomaniacal artist types love it when our input is allowed and encouraged. I did drawings of the Fates based on Gerald's sketches. They were fantastical creatures that could have gone in any one of a dozen different directions. Gerald drew a sort of squashier version of one, and a more bat-like version of another. It's interesting to see in his original drawings of the three Fates, the number three repeated over and over: three hairs, three lines around the jaw, three fingers."

—Nancy Beiman, supervising animator for the Fates and the Thebans (from *The Art of Hercules: The Chaos of Creation*, Hyperion, 1997)

Opposite: Final designs of the individual Fates.

Above right: Design showing the basic structure of Lachesis's head.

Above left: Pencil sketches to show how Lachesis's head and cowl are formed.

Next page: The Three Fates in the movie, showing how close they are to the original designs.

> ## "Hold that mortal's thread of life good and tight."
>
> —The Fates, *Hercules*

Top: The Fates would cut the thread of life with their shearing scissors, and the life would end.

Above right: Correspondence with Nancy sent by fax.

Right: Picture from Nancy.

Handwritten notes on the sketches:

Maybe Clotho should smiled sideways like a crab.

Shape of the Fates without clothes — ghastly thought

Nancy

I feel Lachesis is a little short in stature. I think this is a better proportion.

Dear Nancy

I think you have interpreted my drawing brilliantly, considering you only had that one drawing of the Fates to go on. You have produced vigorous and lively sketches. I have gone over some of them and I hope that it will be a help to you. I include a drawing of the three together, in order to give the relationship between Atropus and Lachesis. I like the way you have made Atropus a smaller, dumpier figure. I also include a drawing of them all without clothes, in order to give their basic shapes. The main problem I thought was that Lachesis and Clotho looked facially too similar, so I have given Clotho a hooked eagle's nose, and I think that she should be permanently bent double, and maybe even scuttle sideways like a crab. I also include a drawing of Clothos' head coming out halfway down her figure - I once made a theatrical two-legged rhino costume for a musical whose head jutted way below the shoulder line - I include a picture. Perhaps Lachesis' neck could be a vulture neck. I include some drawings of suggestions as to how the hood could work. I hope all of this will be of help to you - please do not hesitate to contact me if you need anything. Do send me things from time to time so that I can see the way things are going, and if you need any quick answers there's always my fax . It was good to meet you.

Best wishes

Top left: An important image, showing my teaching method to the animators.

Above right: Correspondence with Nancy sent by fax.

Right: Letter to Nancy.

THE UNDERWORLD

The following pages feature a selection
of my sketches for various creatures of
the Underworld.

BEAST FROM HADES KINGDOM

Opposite: A host of denizens of the Underworld: Harpies, Furies, and Gryphons stream up from the cracks in the Earth.

Next page: A fun selection of creatures from the Underworld.

A RAPACIOUS AND FILTHY MONSTER PART WOMAN PART BIRD.

CREATURES OF THE UNDERWORLD

SAD MUTANT OF THE UNDERWORLD

DEATH COMES ON VELVETY WINGS TO COLLECT
THE SOUL OK AMPHITRYON

CHARON

Ferryman of the Dead

Charon's job in the underworld is to ferry souls of the deceased over the River Styx, after they've received their last burial rites. In the Disney film, Charon appears as an unnamed ghastly skeleton, devoid of human flesh, who rows Hades to his lair in the Underworld.

Charon poles his boat steadily down the River Styx, carrying the souls destined for the next journey.

Sketches of Charon as he poles his boat and (opposite) film stills of the same scene—with the addition of a slavering Cerberus.

Denizen and Spirits in the Underworld

DEATH ON HIS GHOSTLY STALLION

A KIND OF NEGATIVE EFFECT

CLOAK OF SKULLS

CERBERUS

It is said that a dog is man's best friend. Not so in the case of Cerberus, the terrifying three-headed dog that guarded the gates of the Underworld. Best friend? More like . . . best run!

In Disney's *Hercules*, Cerberus is seen doing his job, guarding the door to the Underworld. When Hades is riding down the River Styx to his home, he throws a big steak to Cerberus—the three heads fight over the steak, gobbling it up. The film certainly makes him seem more dog-like, although he is still pretty terrifying.

If you were to take Cerberus for a walk, how could you possibly ignore his voice of bronze and the poisonous black venom that dribbles from his enormous fanged, stinking mouth? Throw him a ball to chase, and he'll come back with someone's leg . . . maybe yours!

Cerberus

I quite often have second thoughts about designing these characters, and I had drawn Cerberus fairly early on in the process. I was pretty sure about how to approach him, but then had another idea.

At that point, I was told there was no way to go back because the original Cerberus had gone into production!

When I first began my designs for Cerberus, I wasn't sure which way the directors would go with him. So I presented various approaches to his portrayal, from humorous to terrifying. In the final film, terrifying was the direction they took.

CHIMERA

This page: Chimera—a creature with parts taken from various animals

Opposite: Griffin—part eagle, part lion.

GRIFFIN

"At the age of five, at my first school in Cardiff, South Wales, I was renowned and celebrated for drawing the Welsh Dragon. My first taste of the big time."—Gerald Scarfe

I love drawing mythical beasts. They take me away from the realities of this world to the fabulous other worlds of imagination.

MEDUSA

One of Three Gorgans

With looks that could literally kill, Medusa is one of the three Gorgons in Greek mythology. She's known to be hideously ugly—often depicted with wings and hair consisting of snakes.

Anyone who looks directly into her eyes immediately dies and turns into stone. Perseus, however, is curious about Medusa and wants a good look at the mythical beast. He gets around the issue of turning to stone by viewing her in the reflection of a mirror. Because Medusa is the only mortal Gorgon, Perseus is able to slay her by cutting off her head. Legend has it that the blood that sprang forth from her neck gave birth to the winged horse Pegasus. Wait . . . what?!?

Medusa doesn't have a big part in the Disney film, but I wanted to draw her anyway. Her head of hair looked out of control as the snakes writhed. As I worked on her character design, many thoughts and jokes began to appear in the drawings.

I could have drawn her as a dark, menacing Gorgon, her hair alive with twisting, hissing, poisonous reptiles spitting venom. She certainly is a dark, sinister character, but she began to appear in my drawings as a figure of fun.

Various versions of Medusa, plus my favorite 'Wash Night' (Can't do a Thing with It!) on the previous spread.

HYDRA

The destruction of the Hydra is one of the Twelve Labors of Hercules, but in the Disney film, Hercules defeats the terrifying, multi-headed Hydra by forcing a rockslide onto the beast—ostensibly saving two boys who got lost in the rock quarry where the Hydra lives.

I don't mind drawing mythological creatures that have no particular role to play in the story and none of the complexities of the central figures. They're simply there to menace and look frightening, and I'm okay at doing that, so it's really just a matter of finding the right shapes for those creatures.

I did various takes on the Hydra. I would go to Hollywood and show them to Ron Clements and John Musker, or I would just send them constant flows of drawings.

This Hydra scene was where Ron and John decided to put some CGI into the film. They had a sculptor named Kent Melton, who would make wonderful clay models of all the characters. The animators for Hades, Hercules, and the rest of the main characters would have these beautiful models on their desks, which they could turn to see what the character looked like from all angles. They didn't have to use their imagination entirely to see what the character looked like from over the shoulder, the side of the face, or anywhere else. Kent created a model of my Hydra from one of my drawings. And then—and I think this was one of the early instances when Disney did this— they put the model into the computer in a 3D way, so that it could evolve.

Top: Out of all my many designs for the dreaded Hydra, this is the one Ron and John chose.

Above: Kent Melton's faithful model of my design which helped the animators understand the designs in three-dimensional terms.

"The first character to be designed for Hercules was the Hydra. Andy Gaskill did a clay sculpture of a Hydra's head based on Gerald's drawing that for the first time took those incidental swipes of the pen and addressed the issue of 'Is that dimensional detail or is that a surface detail?' That was a big step forward because the clay sculpture got us thinking things like 'What would it look like with its mouth closed?,' and 'How does the jaw move?' That sparked [character designer] Jean Gillmore to do a bunch of strong drawings addressing those things. Then, Kent Melton did a twelve-inch sculpture of the head that startled all of us with its ferocious elegance. Suddenly all of Gerald's little nuances made sense in the three dimensions, like, 'Oh my gosh! There are rings around the eyes and stretch lines on the open jaw.' That's when it came alive and Gerald's designs would work, dimensionally. We knew we were going to be able to make a film that didn't look like any other Disney movie, with incredibly strong and consistent-looking characters."

—Roger Gould, artistic supervisor, CGI (from *The Art of Hercules: The Chaos of Creation*, Hyperion, 1997)

It's a perfect thing to do, really, because the Hydra gains many heads after cutting one off. So you only need one, and then you just multiply the heads with 3D technology. They tried it, but the first attempt didn't look graphic like my drawings. It looked like a typical computer rendering, like they do in football and computer games. It didn't look convincing, and the whole point was to try to keep it looking graphic and keep the Scarfe line, as they said. So Roger Gould, leader of the computer graphics unit—which was totally new—had to redo the whole thing. He adjusted all the sequences to make them look more graphic—which took forever. I remember saying to John, "Wouldn't it have been quicker to do it in the old way, just drawing them?" And he responded, "Yeah, probably, and cheaper, too."

This spread: Four versions of the mythical Hydra.

When computer-generated imagery (CGI) officially came over the horizon, producing animated movies like the wonderful *Toy Story* (1995), everything changed for traditional animators. A heavier emphasis was placed on computer graphics than hand-drawn animation. In the end, though, CGI is another tool by which animated stories are told. What is most important is that they are *good* stories.

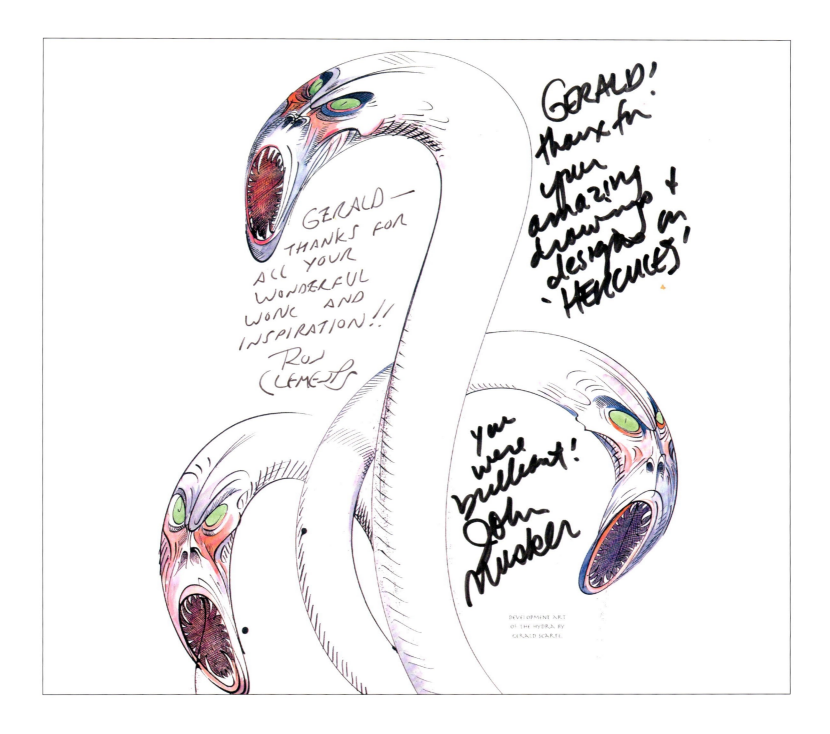

DEVELOPMENT ART
OF THE HYDRA BY
GERALD SCARFE

"Two drawings Gerald had done of the Hydra really spoke to Ron and John—they showed howling, tube-like mouths ringed with sharp teeth, shrieking, anguished faces. These drawings didn't seem particularly dimensional, because Gerald's whole style is graphic, but they were incredibly disturbing. They provoked a lot of dialogue, mostly around the question 'How can we make this the basis for a character design that can be animated?'"

—Roger Gould, animation supervisor, CGI (from *The Art of Hercules: The Chaos of Creation*, Hyperion, 1997)

Above: Ron and John's gratitude for my efforts.
Opposite: I was really inspired by the Hydra.

CYCLOPS

According to Greek mythology, Cyclops were one-eyed giants that lived in a faraway land without law and order. In the Disney film, we first see a Cyclops as one of the Titans imprisoned by Zeus. When he is set free by Hades, he's given a specific task: torturing and killing the weak and powerless Hercules.

The one-eyed, giant Cyclops was terrific to design. Over one hundred tons of enormous blubber crashing myopically through the streets of downtown Thebes, flattening everything in his lumbering path.

He was the second one-eyed, fantastic creature to appear in the world of Hercules—the other being Clotho, one of the Fates. Perhaps they could've gotten together . . . although size would've been a problem.

Cyclops

"But, Father, I've beaten every single monster I've come up against. I'm the most famous person in all of Greece. I'm an action figure!"—Hercules, *Hercules*

"I'm afraid being famous isn't the same as being a true hero."—Zeus, *Hercules*

Previous spread: The massive Cyclops destroys the city of Thebes.
From *Hades: The Truth at Last*, Disney Press, 1997.

Above: This has to be my favorite drawing of the Cyclops.

Opposite: Pegasus is startled when the one-eyed Cyclops glares at him through the temple doorway.

THE CYCLOPS COMES TO TOWN

BROW CAN STILL BE DRAWN DOWN EVEN THOUGH THERE IS ONLY ONE EYE

MORE DRAWINGS OF THE BODY TO FOLLOW G.

Cyclops' G.

I THINK THE CYCLOPS SHOULD BE MENACING NOT COMIC

QUITE A LOT OF EXPRESSION CAN BE GAINED BY EXPANDING THE EYE — ENLARGING THE EYE. G

Cyclops

Opposite: An early design for the monstrous Cyclops and film stills of the final look.

This page: Sketches to assist the animators.

TITANS

"Brothers! Titans! Look at you in your squalid prison! Who put you down there? . . . And now that I set you free, what is the first thing you are going to do?"—Hades, *Hercules*

The Titans were immortal beings that ruled the cosmos before the Olympian gods came onto the scene. As the Fates had foretold, when the planets were aligned, it was time for the Titans to scale Mount Olympus and overthrow Zeus and the other gods. Each Titan was represented by the element it controlled: mud, rock, wind, or ice, to name a few. After being imprisoned under the earth for so many years, they were dying to get out . . . and to wreak havoc.

Above: A soldier of Thebes looks on in awe as a monstrous Titan rears above the distant mountains.

Below: Three Titans, by the light of an active volcano.

Opposite: Another fearsome Titan!

Next page: The lava Titan moves relentlessly forward, consuming all before his path.

WATER TITAN

MUD TITAN

This page: Mud Titan—sliding like an ever- running river of glutinous mud and treacle, smothering all in its path.

Next page: The Titans before they are released from their prison.

THE TITANS ARE IMPRIS

I HATE MONDAYS

ROCK TITAN

TITAN EMERGES FROM THE DARK PIT OF TARTARUS

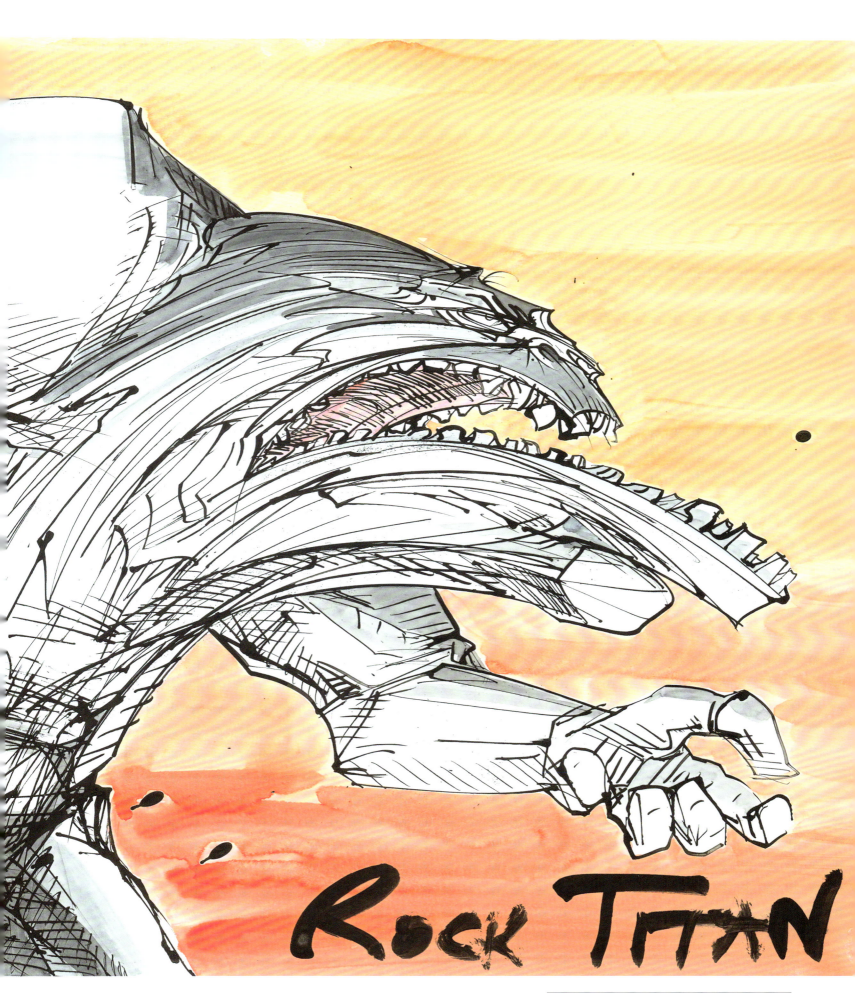

ROCK TITAN

The Rock Titan—hard as granite, crunching and heavily grinding his rocky way, with cumbersome thundering footsteps. Or maybe, more like a rockslide?

WIND TITAN

Drawings of the wind Titan, howling like a tornado.

ICE TITAN

I FEEL THAT THE PRECISE JAGGED EDGES ARE MORE IN KEEPING WITH ICE.

G.

Some examples of my instructions to the animators to make their lines more jagged, indicating the sharp edges of ice.

THE ICE TITAN RISES— CRACKING ICE

ICE TITAN

Ice Titan
TURNS EVERYTHING HE TOUCHES TO ICE

This spread: Three designs for the mountainous, glacial and threatening Ice Titan.

"As the Fates had foretold, when the planets were aligned, came the time for the Titans to scale Mount Olympus and usurp and overthrow Zeus and his empire. And instate Hades in their place."
—Gerald Scarfe

Hades, in his chariot, rides alongside the Titans.

This spread: Hercules, mounted atop the sturdy Pegasus, attacks the Titans, aided by Zeus and his thunderbolts. From *Hades: The Truth at Last*, Disney Press, 1997.

Next spread: Film still of the Titans attacking Mount Olympus.

AIR

THE CLOUD SHAPES ADD TO THE TURBULENCE OF THE AIR BATTLE

WIND

The West Wind and the East Wind have a contest.

Summer Wind South

The North Wind

Top: A windy day on Mount Olympus.

Above: A sunny day.

Right: An icy day.

MOUNT OLYMPUS

Soaring miles above the pink and white clouds, towering majestically in the clear blue sky and high above the verdant lower slopes stood Mount Olympus. Home to the gods, Mount Olympus served as a kind of rampant suburbia!

"In designing the color, we tried to establish a more limited and unpredictable palette. We had to push the color to marry with the already stylized characters and layout drawings. This drawing style was influenced by Gerald's designs and ancient Grecian patterns. There is a common thread that runs through the characters and backgrounds. For instance, you will notice that the grass in the movie swirls around in 'S' curves, which echo Scarfe, and the rocks have Greek key designs in them."

—Thomas Cardone, artistic supervisor for backgrounds (from *The Art of Hercules: The Chaos of Creation*, Hyperion, 1997)

APOLLO

God of the Sun

Apollo, a beautiful, charming, and charismatic youth, was the god of many things—mainly the sun, healing and disease, truth and prophecy, archery, dance, and music. While he was feared by most of the gods, few could resist his wiles.

Legend has it that one day, when Apollo was away on business, he left a crow to watch his pregnant young girlfriend, Coronis. When the crow flew to tell him that Coronis had married another, Apollo went into a violent rage and turned the crow black. But why blame the messenger?

In the end, Apollo slew Coronis and her new husband, Ischys. Apollo also established the Oracle of Delphi after taking on the guise of a dolphin, leaping on board a Cretan ship, and forcing the crew to serve him. It's hard to believe some of these stories, and the Disney version of Apollo wouldn't believe them either!

Two early versions of Apollo and my clean-up guidance for the final model.

Apollo BLAZES ACROSS THE HEAVENS

89

> HADES
> Thanks a ton, Wonder Boy!
> Eighteen years work, all down
> the drain!
> (smiles)
> But at least I got one swell
> consolation prize. A friend of
> yours who's <u>dying</u> to see me...

The fissure closes around Hades just as Herc reaches it.
Herc pauses, wondering what he meant. Then it hits him.

> HERCULES
> <u>MEG</u>!!

EXT. THEBES

As Phil is tending to Meg, her eyes shut. A dark shadow
looms over her. Phil looks up to see DEATH, the most
terrifying God of all, approaching. His black, plumed helmet
frames a pair of pitiless eyes. His powerful body, encased
in mail, moves forward inexorably.

INT. DOMAIN OF THE FATES

Atropos sits poised with the thread of Meg's life. She
raises her scissors.

EXT. SKY

Herc and Pegasus gallop madly through the clouds.

INT. DOMAIN OF THE FATES

Atropos opens the scissors and moves them toward the thread.

EXT. SKY

Herc and Pegasus descend dizzyingly through the clouds toward
Thebes.

INT. DOMAIN OF THE FATES

The poised scissors FLASH and cut Meg's thread of life.

EXT. THEBES

Herc soars into the city, leaps off Pegasus and rushes to
Meg. He lifts her in his arms. Her head lolls and her body
sags limply. Herc tries to revive her, but it's no use.

> HERCULES
> Meg... Meg, no...

Handwritten text within sketches:

Apollo's chariot. A blazing fireball

APOLLO'S CHARIOT.

I CHANGED ZOLTANS HORSES HE HAD DRAWN FOR ARES CHARIOT INTO BULLS WHILST I WAS IN PARIS — S.

Opposite: A page from the original printed script showing how, before the characters are designed and finalized, scenes are being envisaged with dramatic camera angles and exciting filmic visions.

This page: Sketches for Apollo's fiery chariot and (below left) Hades's terrifying transportation. and Ares (above) Ares gets bulls instead of horses to pull his chariot.

ATHENA

Goddess of War and Wisdom

Zeus's favorite child, a battle-loving chaste goddess—very unusual! Some legends suggest that Zeus swallowed his wife, Metis (the goddess of counsel and cunning intelligence), while she was pregnant with Athena because she had warned him that their child would overthrow him one day.

However, shortly after these events, Zeus experienced a splitting headache. He asked one of his sons, Hephaestus (definitely not a qualified doctor), to split open his skull with a bronze axe. From the crack in his head came Athena—a fully grown woman with body armor, a shield, and a lance . . . prepared for battle right at birth! This traumatic and disturbing delivery gave rise to a moral and intellectual goddess who represented the heroic ideal of war, along with the virtues of justice.

Left: Athena seen here with her little owl of Athens.

ARES

God of War

Ares is the bloodthirsty, cruel, despotic god of war—directly in contrast to his half-sister, Athena, a more reasonable warrior goddess who represented intellectual aspects of war, along with the virtues of justice. But really. . . what is reasonable about war?

It has always been amazing to me that there are rules to war—mostly broken, of course, by those who are involved. In medieval times, two armies would march to a field, set up camps facing each other, and light fires where they would cook hearty evening meals— they would eat, laugh, and tell some bawdy tales. They would fall into an uneasy sleep, rise in the early morning, wash (I doubt it!), and then advance to fight one another. Nowadays, warfare is like a zap from the skies—a lightning bolt from Zeus.

"He was pretty war-like. Is there a
Greek god of peace?" —Gerald Scarfe

"I saw him as pretty inept: in my vision a figure of fun unable himself to fight a bumblebee, sending hundreds of young men to early deaths by making ridiculous decisions. In all, a terrible, horrific figure of fun." —Gerald Scarfe

6/20/96

Dear Gerald,

Hello! I just wanted to let you know the outcome of our gods style meeting which happened on Wednesday morning.

All the designs were pretty close but some adjustments are being made in clean up to some of the characters. Here's what was decided:

Poseidon -
We're going to push his eyes to be more bulging as indicated in your drawings as well as using a nose more like the one you drew that will hook more.

For simplicity reasons the directors felt it best to stay with the fish tail beard, but use the moustache you designed.

We'll also be enlarging his back fin to match what you have done.

Ares -
We liked one of the drawings you did which indicated Ares as being bald. We're going to try going with that (but keeping his beard, of course.)

We also liked the more designy nose you used for him.

Athena -
Her straight nose is good. We're going to go with the overall wider features which were displayed in one of the drawings you sent us.

We'll be adding a pupil and iris to her eyes.

We liked the contrast of the curvature of her chin against the horizontal straights of the rest of her face.

BACCHUS

God of Wine and Revelry

When designing the character for the film, I saw Bacchus as I imagine most do: a jolly, rotund imbiber with a ruddy complexion and perhaps a bulbous nose, misshapen by too much wine.

He walked with an unsteady, rolling gait . . . when he could walk, that is. Bacchus would rarely be without a glass of wine in his hand or far from a cask. Around his head, he wore a wreath of vine leaves, slightly askew and slipping down over one eye. I thought he would have been extremely popular amongst his fellow gods, with his constant convivial greeting of "Fancy a quick one? Cheers!"

HEPHAESTUS

God of Fire and Metalworking

Represented by common smithing tools such as the hammer, anvil, and tongs, Hephaestus is the god of smiths, craftsmen, metalworking, stonemasonry, and sculpture. Often depicted near fire, Hephaestus created weapons for the gods and some mortals, such as the winged helmet of Hermes and armor worn by Achilles.

Simple Shapes

HEPHAESTUS

HEPHAESTUS

HEPHAESTUS

HEPHAESTUS

HELLO GERALD!

HERE IS SOME STUFF I WAS HOPING YOU COULD
GO OVER. APOLLO SCREAMS "HERCULES!" SO THAT
EXPLAINS HIS ACTIONS. THE OTHERS JUST REACT
THANKS FOR YOUR TIME AND IF ITS AT ALL POSSIBLE
TO GET THESE BACK SOON I'D BE BEHOLDEN

THANKS AGAIN.

DAVE ZABOSKI

Opposite: Hephaestus confronts a fiery demon in his forge.

Top left: Four sketches of Hephaestus, showing different positions and his wooden leg.

Top right: Hephaestus the blacksmith.

Above: My cleaned-up versions of Apollo, Aphrodite, and Hephaestus.

HERMES

Messenger of the Gods

One of the most clever and mischievous of the gods, Hermes was the herald and messenger for his friends on Mount Olympus. He is known for his impish behavior, often playing tricks on the other gods.

Busy little fellow—hither and tither, back and forth between the gods as their errand boy. I wondered what sort of message he was carrying . . . "Can you bring back my lyre? I've got a gig on Friday. Yours, Apollo."

Hermes — Messenger of the Gods

This spread: I first saw Hermes as the messenger boy, flying hither and thither running errands for the gods. But John and Ron decided he should be based on musician Paul Shaffer, at the time known as the band leader on *Late Night with David Letterman*. He was very popular at the time. In my design I put aerodynamic wings on his hat and shoes.

"Why, Hermes, they're lovely." —Hera, *Hercules*

GERALD,

PLEASE LET ME KNOW YOUR
WAY TO IMPROVE THIS DRAWING
OF HERMES SOUNDING THE ALARM
THANK YOU.

MARC

"I had Orpheus do the arrangement. Isn't that too nutty?" —Hermes, *Hercules*

The voice actor playing Hermes in the film was the bandleader on *Late Night with David Letterman*, Paul Shaffer. According to Greek mythology, Orpheus is known as "the father of songs," so he would actually be the perfect choice to do an "arrangement."

MARC —
THANKS FOR YOUR
FAX — I HOPE
THESE DRAWINGS
ARE A HELP —
GERALD

LONGER
UPPER
LIP

Left and opposite: Fax correspondance to help fine tune Hermes and opposite my sketches to show Hermes in flight.

60's hallucinogenic

60's mini skirt
He turns - flies upside down
wings going like mad
silly little skirt
Baudy?

Hermes into
Banks
Steeply

HERMES BANKS
STEEPLY

...EUS

...d Dreams

...heus rides a
... pulls a dark,
..., enveloping the
...as they descend into
their deep slumber.

Sleepy fellow, he tends to drop off during
conversations, which can be annoying.
Also it's very possible that Morpheus
may have been a loud snorer,
which can be also be irritating . . .
or so my wife tells me.

Sleepy old Morph. Made
me feel tired to draw him.

MORPHEUS AND HIS BILLOWING CLOAK OF DARKNESS

POSEIDON

God of the Sea

Poseidon was the god of the sea (and water in general), earthquakes, and horses. He's one of Zeus's brothers—along with Hades—and joins him on Mount Olympus. Poseidon is often seen with a trident, or a fishing spear.

Fins, gills, scales, seaweed, and trident: I assembled all the images I could think of for clues to Poseidon's persona. And eventually, from my mind and pen, he swam onto the paper.

Incidentally, when the domains were divided up amongst the three brothers—Zeus, Hades, and Poseidon—Poseidon got the sea. Personally, I think he got a raw deal as a place to dwell. It's nice for a swim but very damp and cold to live in. He might have preferred Zeus's glorious, sunny heavens or even Hades' warm underworld.

POSEIDON

POSEIDON RIDES THE WAVES

Previous spread: Poseidon rides the waves. The breaking waves take the shape of galloping horses.

This spread: Poseidon was a great character to create. This is a selection of some of my versions of the water god.

SEAWEED BEARD

POSEIDON

SEAWEED HAIR

Puffa Fish

Poseidon's guard

PROTRUDING FISH EYES
BALD HEAD WITH FIN
EARS AS GILLS
SEAWEED BEARD
AND EYEBROWS —
WEBBED FINGERS

POSEIDON

HERCULES AND THE SEA MONSTER

Opposite: Poseidon evolves.

Above: Poseidon, and some of the other gods, as they appear in the final film.

SUN GOD
BEACH BUM
FROM
MUSCLE BEACH

ALWAYS
PUTTING ON
SUN CREAM

HYPERION

OTHER GODS

There were many other gods I drew that didn't appear in the final film. They were, however, used in the TV series that came later.

Top: I liked the idea of the flashy, show-off sun god, Hyperion, continually oiling his well-toned body on muscle beach.

Right: The goddess of love, Aphrodite.

Opposite: Sketches for (top) Demeter, goddess of the harvest, (bottom left) Psyche, goddess of the soul, and (bottom right) Nike, goddess of victory.

ANOTHER DEMENTER

YET ANOTHER DEMENTER

PSYCHE BUTTERFLY

NIKE

ANCIENT GREECE

AMPHITRYON

Adoptive Father of Hercules

In the Disney film, Amphitryon is depicted as a frail older man with kind eyes and a sense of compassion for his son—despite the fact that the young Hercules almost ruined their small town while playing a game of Frisbee!

This spread: Several versions of Amphitryon pictured here.

This page: My notes and directions about the progress of Amphitryon.

Opposite: Three more drawings of the final version of Amphitryon and (below) Amphitryon and Alcmene as they appear in the final film. Here for the first time discovering the abandoned baby Hercules.

"I was very intimidated about working with Gerald at first because he is such a big name in England, where I'm from. I've known his work since I was very young, and his pen is almost like a savage weapon. I studied and studied his work to see what I could get into my designs of his quirky, Gerald-type symbols and shapes. On the retreat [in Santa Barbara], we'd do drawings, and, you know, you always become a little possessive of your own work. But Gerald would make suggestions, and then take our drawings and sketch over them. We had a major difference over the size of Amphitryon's ears, and he'd gone back to England, so I bugged him constantly with faxes. I always thought he'd want to make the ears bigger, but he said, 'For this design, it's going to work better smaller.' And he was right, because Amphitryon is a warm character and needed to look a little softer, not comical. It was a struggle, but it finally worked."

—Richard Bazley, supervising animator for Amphitryon and Alcmene (from *The Art of Hercules: The Chaos of Creation*, Hyperion, 1997)

ALCMENE

Wife of Amphitryon and Adoptive Mother of Hercules

I imagined her as a warm, curvy, motherly woman. She and her husband found Hercules as a baby when Pain and Panic abandoned him after kidnapping him from his cradle. Amphitryon and Alcmene immediately adopted the foundling and brought him up as their own.

SIDE VIEW TRICKY — BECAUSE NOSE STARTS TO LOOK PORCINE —

ALCMENE

Sympathetic eyebrows

Hair slightly disarranged Busy fussing step mother

Watch wrists getting to exaggeratedly small Difficult to find the character

TO GERALD FROM RICHARD DISNEY '97

Note to animator Richard, with my thoughts and directions about Alcmene's character.

PENELOPE

Amphitryon's Pet Donkey

Penelope is an adorable pet donkey that dons a blue handkerchief and is present for some of Hercules's earliest adventures. She puts up with Hercules as he is learning his strength, and even sprains her ankle at one point. Hercules comes to Penelope's rescue by pulling her wagon in order to deliver their goods to the market. A joy to design.

CITIZENS OF THEBES ("THE BIG OLIVE")

The city of Thebes is often a central point in many tales from Greek mythology.

When the Thebans first appear in the film, they complain about how Thebes is in turmoil—between earthquakes, fires, floods, crime, and, of course, monsters. But Snowball the cat survived the fire. Phew! When Hercules approaches them, fishing for someone to save in order to prove his worth, they don't believe that he's a real hero, and they walk away. But when Meg warns Hercules of two boys trapped in a gorge by the dreaded Hydra, the Thebans follow to see what this hero is truly made of.

THE END IS COMING!

Left: Earthquake lady.

Above: End of the world guy.

Opposite: A merchandise salesman of Thebes.

MERCHANDISING
SALESMAN
—THEBES

EARTHQUAKE LADY

Top: Chariot driver.

Above: Earthquake lady.

Right: An approved model sheet of the character.

Opposite: There are some strange goings-on in Thebes . . . strange indeed—very strange!

TWO CITIZENS
DISCUSS THE
RECENT STRANGE
HAPPENINGS
IN
THEBES

DEMETRIUS

PLEBECCA
HERE ARE DEMETRIUS
'A WALKING TENT'
AND 'ITHICLET' GERALD

NOV 12

"Valse Painter"

This page: A colony of vase painters ply their art for sale in Thebes, painting famous Herc's picture.

Opposite: The initial design and a note to Rebecca Huntley (bottom left), who handled my designs at Disney, and (top) Demetrius, the vase salesman, looks apprehensive as a clumsy young Herc hurtles toward him and his precious vases, off balance and out of control as seen in the final film (right). One can only imagine what became of Demetrius. Did he perhaps make his way to Thebes with Hercules?

WHITE HAIR?

WHITE STUBBLE

END OF THE WORLD GUY

The "end of the world is nigh" guy: naked,
but for a pillar as clothing.
This prophet of doom shouts his warnings
to all and sundry.

"For some of the minor characters in the film, I would start with an image, which I would try to perfect or turn to my illustration style. When viewing some of my early drawings for the film, they're not like Disney's animation style at all. They're just different ideas of different people." —Gerald Scarfe

Various citizens of Thebes including (left) man with his little dog, my first drawing of the heavy-set woman (top left) looking rather operatic and cleaned-up version of the bearded man (top right).

BURNT MAN AND SNOWBALL THE CAT

The burnt man, with his long-suffering cat, Snowball, after they survived a Theban fire and (opposite) a crotchety old man. I must admit, I see a touch of myself in this character.

OLD MAN OF THEBES

Three soldiers of Thebes and (opposite) the sundial salesman, concealing a horde of sundials beneath his voluminous black cloak. In the film, the timepiece salesman is considerably more friendly than my conman design.

SUNDIAL SALESMAN

HERCULES

The Muses

| Calliope | Thalia | Clio | Melpomene | Terpsichore |

This Spread: The cast of characters all sized up and ready for animation.

<u>Ruff Size</u>
<u>Comparison Chart</u>

3/12/96

Pain Hades Panic Amphitryon Young Herc Alcmene

Hermes

Baby Pegasus Baby Herc Zeus Hera The Fates

Nessus Megara Phil Hercules Pegasus

Hercules to the Rescue

MEG'S SOUL FLOATS SLOWLY DOWN the river of souls, while Hades encourages Hercules to dive in and save her life.

Above: Artwork from *Hades: The Truth at Last*, Disney Press, 1997.

Opposite: Film stills of the same scene. Herc dives into the River Styx to save his beloved Meg. Although his strength is waning, he musters enough energy to bring her back to safety. Hoorah!

Hercules triumphing in the end, ready to live happily ever after and (above) a happy family group, with foster parents Amphitryon, Alcmene, and, of course, Penelope the donkey.

*"I wish to stay on Earth with her.
I finally know where I belong."*
—Hercules, *Hercules*

The Premiere

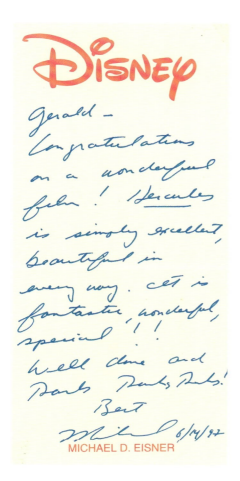

Disney

Gerald –
Congratulations
on a wonderful
film! Hercules
is simply excellent,
beautiful in
every way. Cut is
fantastic, wonderful,
special!!
Well done and
Thanks Thanks Thanks!
Best
Michael 6/19/97

MICHAEL D. EISNER

Above: "So you're the guy that goes behind all this," said Michael Eisner, former CEO of The Walt Disney Company, at the premiere. He later sent me this congratulatory note.

Opposite: A float passes down 42th Street in New York during a parade for the release of Disney's animated movie *Hercules* 14 June, 1997. The parade caused much of the theater district to shut down.

I showed my daughter, Katie, a photograph of me shaking hands with an unknown, (to me, at the time) young woman. "Oh my God!," she said, "That's Jennifer Aniston! You met her???." Nothing I've done has impressed her quite so much. Tate Donovan came to tea with us at our house in Chelsea. Unfortunately, Jennifer was out of town.

BEFORE THE PREMIERE OF THE FILM in New York City at the New Amsterdam Theatre, Disney rented an ice rink and covered it with boards. On top they built cubicles—one for producer Alice Dewey, one for John Musker, one for Ron Clements, and one for me.

The four of us sat there all day for two days, doing fifteen-minute interviews, with very short breaks in between. An interviewer would come into my cubicle, which was installed with two automatic cameras: one on the interviewer, one on me. Once the interview was over, after exactly fifteen minutes, the interviewer would leave, carrying both tapes to edit at will, and another interviewer would come in to ask more or less the same set of questions. I can't remember what I said or not to those interviewers . . . It was all pretty a script on repeat. A bit of a blur in the end.

The premiere itself was to be celebrated with a parade down Fifth Avenue culminating at the place where I was to be seated, with floats, bands, tumblers, etc. At the same time, I was being filmed for *The South Bank Show* (a British television arts show) about my experiences at Disney. The crew arrived early and had their camera set up to zero in on my designated seat in the front row. It was on a set of bleachers that was built especially for the occasion. When my wife, Jane, and I arrived at the parade, we were taken to our seats by a young usher, but just as I was about to take my seat, a man plonked himself down in it and pulled a five-year-old child onto his lap. When I said, "I think those are our seats," the man just glared at me. I said, "I am the designer of this film, and I would really like to sit here in my seat." He just clutched the toddler even tighter, and eventually I felt I had to give in.

So the usher, Jane, and I walked down the bleachers to the far end—the no man's land—where we sat at the very top. The poor *South Bank* crew had to run down to me holding a tripod and a camera. If you watch the *South Bank* footage, you'll see I'm up at the back of the crowd somewhere.

Later that evening, the celebration continued with a party at Pier 42, where Michael Bolton sang "Go the Distance," standing on the pier with his long hair blowing in a fierce wind off the

Buena Vista International (UK) Limited
invite you to attend
the UK Charity Premiere of

Walt Disney Pictures
presents

HERCULES

in aid of the British Red Cross
Anti-personnel Landmines Campaign
in tribute to the work of
Diana, Princess of Wales

on Thursday 9th October
at the Odeon Leicester Square
London WC2

6.30pm doors open
7.30pm please be seated
(STRICTLY NO ADMITTANCE AFTER 7.45 PM)

7.50pm film starts
9.20pm carriages

ALL OF THE NET PROFITS OF THE PREMIERE EVENT WILL BE PAID TO
BRITISH RED CROSS EVENTS LTD, WHICH COVENANTS ALL ITS TAXABLE PROFITS TO
THE BRITISH RED CROSS SOCIETY, A REGISTERED CHARITY NO. 220949

TRAFFIC IN THE EARLY EVENING THE ROADS AROUND LEICESTER SQUARE ARE HEAVILY CONGESTED AND
THEREFORE WE RECOMMEND THAT YOU SET OUT EARLY FOR THE CINEMA.

SECURITY: DUE TO STRICT SECURITY ARRANGEMENTS FOR THE EVENING, GUESTS ARE ASKED TO PROCEED TO
THEIR SEATS IN THE AUDITORIUM IMMEDIATELY ON ARRIVAL. AT THE CINEMA, GUESTS SHOULD NOT CONGREGATE IN
THE FOYER OR ON THE STAIRS.

CIRCLE
PLEASE ENTER CINEMA BY LEFT HAND DOORS

ODEON C 25
LEICESTER SQUARE NO SMOKING DRESS: FOR THE GODS

Above: My movie ticket for the British premiere in Leicester Square, London.

Hudson River. I had met Michael before, when he turned up at a special party given for me by Disney and Tina Brown at the Z Gallery in New York, where Michael stayed the obligatory twenty minutes.

When I did the publicity tour across Asia, it was great fun because I had my wife, Jane, and my two sons with me. But in Tokyo, while I was sitting in the hotel, my family, was looking at Japanese shrines and temples, going to Disneyland and having a great time, while I was answering the same old questions again and again. I remember Alice Dewey said to me, "When they ask you, 'Do you have a hero?,' what do you say?" I said, "Nelson Mandela." "Oh, that's a good idea. It's a tricky question," she said. I've kind of lost touch with Alice, but she was a very good friend to me at the time—Ron and John, too.

I was sad when it all finally came to an end. I had been very pleased and flattered to be involved, and I was proud when they told me that only one other designer from outside the Disney fold had ever been invited to work with the studio: Salvador Dalí. He was invited by Walt Disney himself to work on a film called *Destino*. The film never came to fruition during Dalí's lifetime, although it was eventually revived and released in 2003.

"At the end, during my publicizing of the film—what with the first-class flights, limos, and hotel suites—it was the nearest I'll come to being Tom Cruise."
—Gerald Scarfe

I'm delighted to hear that hand-drawn animation is coming back, despite the threat of CGI and AI technology taking over. There's nothing quite like your hand touching the paper, the human brain drawing through the arm. When you visit an art gallery, you see the canvas that Henri de Toulouse-Lautrec actually touched. He sat in front of that very painting that you're looking at, and he put his personal thoughts and emotions into it. Whereas, of course, when you hear a Beethoven symphony played, it's an interpretation by the musicians and the conductor of Beethoven's score.

Top left: My wife and our two sons, Alex and Rory, ride down a water chute at Tokyo Disneyland—having fun while I do endless tail to tail, nonstop 15-minute interviews in my hotel room during the film's Japanese premiere (opposite).

Top right: My son Rory peeps around a publicity cutout on display in Taiwan during our tour.

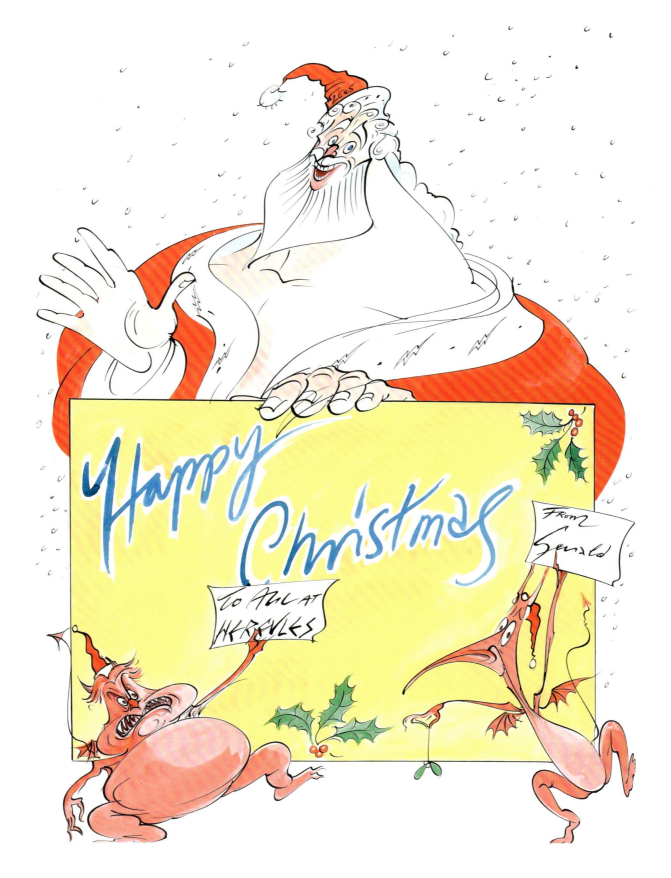

Above: A 1997 Christmas card I drew for the animation crew and staff.

There's nothing quite as pure as something directly touched by the human hand, and hand-drawn animation is the nearest one can get to human involvement.

Each generation tends to have its favorite Disney film. For my wife, Jane, it's *Cinderella*; for my son Rory, it's *The Lion King*; for me, it will always be *Pinocchio*. To my delight, for many in this generation . . . it's *Hercules*. I am extremely proud to have been involved.

Top: I spent a day with my daughter, Katie, walking around the shops of Manhattan. We bought some of the amazing copies and model toys of my creations. This is just a small collection of them.

Above: Disney was kind enough to throw a party together with a selection of my work.

Right: Disney held an exhibition of my *Hercules* designs in the main animation building in Burbank.

Seventy Years of Scarfe

I HAVE BEEN A PROFESSIONAL ARTIST, making my living by my art, since I left school at the age of 16 in 1952. I did not go to art school and was a chronic asthmatic from birth, which resulted in a very erratic and scattered education. My parents thought I would be reliant on them for the rest of my life, but I had the luck to be good at art, and it has been my saviour and way of life ever since. I have worn many hats.

I am a political cartoonist; illustrator; sculptor; set and costume designer for stage, screen, rock and roll; and writer, designer, and director of animation. I have directed, written, and appeared in many television programs; had exhibitions of my work around the world, from Los Angeles to Melbourne; and sent reportage—drawings made on the spot—from Vietnam, the Six Day War in the Middle East, the cholera epidemic in Calcutta and many more. I was arrested in Egypt, shot at in Vietnam, held at gunpoint both in Paris and also in Belfast, when being hijacked by the IRA. I have drawn many celebrities from life, from Arnold Schwarzenegger to Mohammed Ali, from Churchill to Nixon, so it has been fun. Here follows some of the moments from the last 70 years.

In my Cheyne Walk studio, London, 2019.

1960s

SCARFE'S STUDIOS

My parents thought an artist was not a "proper job". It was hoped I would follow my father into accountancy. Luckily for me, I failed all requirements and ended up in my uncle's commercial art studio. Those years did teach me to draw faithfully—sadly, whereas Andy Warhol's Campbell's soup tin rose to fame, my marmalade pot fell into obscurity.

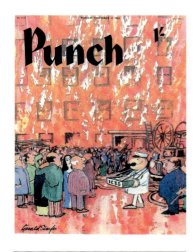

PUNCH

Punch was the most prestigious satirical magazine of that era. Having tired of comic jokes, it was here that my darker, ironic humor, which became my trademark, began to appear and was later picked up and polished by *Private Eye*.

BERLIN

Esquire magazine sent me to postwar, bomb-devastated Berlin in 1964. Berlin. This drawing commemorates a 16-year-old Esat German boy who climbed the wall to escape to the West and was shot on the top of the wall and fell backwards onto the East German side and was, inhumanely, left to bleed to death at the base of the wall.

LYNDON BAINES JOHNSON

I was sent by the *Sunday Times* to fly with LBJ's 1964 campaign tour across the U.S. to Cleveland. When I asked him to sign my drawing, I was grabbed by two security guards, who thought I was going to assassinate him with my rolled-up drawing.

THE SWINGING SIXTIES

In 1966, I bought No. 10 Cheyne Walk in Chelsea: a fabulous four-storey Victorian house by the River Thames, with stunning views of the river and Albert Bridge. Mick Jagger and Jimi Hendrix were neighbors. It was five minutes from the famous Kings Road, with its "Swinging London" bars, restaurants, pubs, and clubs, and a constant parade of fashionable young people wearing Biba and Mary Quant. I lived there for over 50 great years.

WINSTON CHURCHILL

When sent by the London *Times* newspaper, I made this drawing of the aging war hero on his last visit to the House of Commons. The *Times* refused to print it because they thought it so truthful that his wife, Clementine, would be upset when she saw it. It was later used on the cover of *Private Eye* when he passed away.

THE *DAILY MAIL* AND VIETNAM

I joined the *Daily Mail* in 1966. They sent me to create reportage drawings at the height of the Vietnam War. I lived with the Marines and traveled the troubled country by helicopter. I saw scenes I will never forget.

DRAWING FROM LIFE

Encounter Magazine sent me to draw a group of New York intellectuals. The drawing above is of Robert Oppenheimer, the creator of the atom bomb. My editor said "He looks like he's wondering what he's done!" I also drew from life composer Igor Stravinsky, Leonard Bernstein, Mark Rothco, Arthur Miller, Barnett Newman, Larry Rivers and others.

VIETNAM

This drawing of LBJ defecating bombs over this troubled area was made for the *New Statesman* in 1967.

THE *SUNDAY TIMES*

In 1967, I joined the *Sunday Times*, under the editorship of the legendary Harold Evans. He first used me for reportage drawings: the Six-Day War in Israel, the Cannes Film Festival, a Lancashire coal mine and, later, to Northern Ireland—where I was hijacked at gunpoint. I spent 50 years as the *Sunday Times* political cartoonist—50 years!!

BOBBY KENNEDY

In 1968, I flew with the charismatic Bobby Kennedy in his personal jet to draw him for *Fortune* magazine on his campaign tour. Later, I was staying in the same hotel—the Ambassador, in LA—when he was shot in the kitchen. I was devastated.

THE BEATLES

I followed the Beatles around for a week. I sketched them when they were filming *Help!* at Twickenham Studios and then at their homes for more sketching. John told me, "You're a cynic, Gerald, like me."

HUNG BY SCARFE

My one-man-show at the Grosvenor Gallery in London, in 1968. It later transferred to Chicago, where John Musker saw it. I appeared on the Johnny Carson show with some of the sculptures, including George Wallace, hanging by one arm like an ape, and Nelson Rockefeller with solid gold teeth. Rockefeller bought his sculpture to adorn the top of his stairs in Gracie mansion, his home.

RONALD REAGAN

Papier-mâché sculpture of Ronald Reagan for an exhibition at the Waddell Gallery in New York. I was very fond of Ronnie. I worked in papier-mâché a lot during this time, for exhibitions and *Time* covers. Unfortunately, being fragile, they were often destroyed on tour. Also they were eaten by biscuit beetles (ironically, in the case of my *Time* cover of The Beatles.)

RICHARD NIXON

Nixon's team, I was told, did not want me on the trip, having found out what type of work I did, but *Time* magazine, being omnipotent, got me on the plane. At the first venue where he made his campaign talk, Nixon, seeing me sitting in the front row, said "Hi Gerry! Are your pencils sharp today?" They were! During this period I always flew with Barry Goldwater, Nixon's opponent, who said of my portrait of him, "Sure I'll sign it – I've got a sense of humor!"

ROWAN AND MARTIN

I sailed on Dan Rowan's yacht on the Pacific to illustrate this *Time* cover. Incidentally, that's me in the bottom right-hand corner, dressed as the German *Laugh-In* character Wolfgang: "Veeery interesting . . . "

1970s

GERALD SCARFE 60-70

The London exhibition (originally entitled *Hung by Scarfe*) featuring my papier-mâché sculptures and prints, moved to the Waddell Gallery in New York in 1970 and then went to Montreal.

OSAKA, JAPAN

A gigantic sculpture of Gulliver, welded from scrap metal for the British government's exhibit at Expo '70 in Osaka, Japan. It was accompanied by other sculptures of characters from British literature: Long John Silver, Alice, Mr. Pickwick, Sherlock Holmes, etc.

CHAIRMAN MAO

I made this sculpture of Mao out of an old armchair for an exhibition at the National Portrait Gallery in London, called *SNAP!*, which featured three portraitists: David Bailey, David Hockney, and me.

NIXON *TIME* COVER

A sculpture commissioned by *Time* magazine that never made it onto the cover. It was deemed "too offensive."

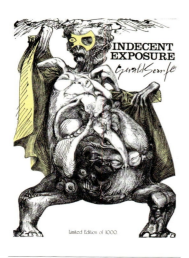

INDECENT EXPOSURE

This 1973 self-published limited edition contained my latest work at the time. Followed it up a year later with 'Expletive Deleted', a book of drawings of Richard Nixon.

WISH YOU WERE HERE

Illustration of "Leaf Man Tumbling."

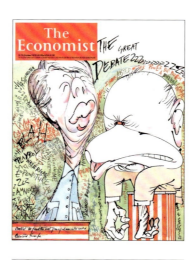

THE *ECONOMIST*

The cover shows the debate between Jimmy 'Peanut Farmer' Carter and Gerald 'Can't Walk and Chew Gum at the Same Time' Ford in 1976. Carter was elected President.

THE *SUNDAY TIMES*

1976

1980s

PINK FLOYD

My gigantic inflatable of "The Mother" for Pink Floyd's *The Wall*, being rehearsed at Earl's Court, for the first tour in London, Dortmund, and America.

PINK FLOYD: THE WALL

Poster with the Screaming Head for the MGM film *Pink Floyd: The Wall*.

BELGRANO

During the Falklands War, Mrs. T. is accused of sinking the Argentine ship, with a huge loss of life, as it sailed away from the war zone. Here she has nightmares.

MARGARET THATCHER

Statue of Maggie Thatcher, destined for a public place, as she stands upon the Tomb of the Unemployed. This was created for my solo exhibition at the Royal Festival Hall in London.

PROS AND CONS

Roger Waters and I collaborated once again on his new album *The Pros and Cons of Hitch Hiking* in 1984. Rog and I came up with a wastrel, druggie mongrel called Reg. His name being a combination of the second part of Roger (GER) and the first half of mine (GER) backwards, REG.

ORPHEUS IN THE UNDERWORLD

Seated beneath a huge stage cloth painted for the comic operetta by Offenbach. I designed the costumes and scenery for the 1985 production of *Orpheus in the Underworld*.

GALA POSTER FOR *O IN THE U*

This was a huge success and ran for many years, including in Los Angeles, Seattle, Houston, and New Zealand in 1984.

SCARFE ON SCARFE

I wrote, directed, and acted in this autobiographical film for the BBC, painting scenes from my life on the walls of a room. It won me a BAFTA (seen here celebrating with my wife, Jane). I followed it with a series called *Scarfe On* and other films.

1990s

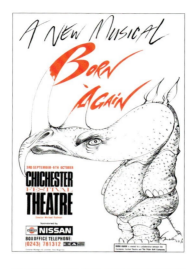

RHINOCEROS

Born Again, a 1990 musical based on the Ionesco play Rhinoceros, was directed by Peter Hall. It ran at the Chichester Festival Theatre in the U.K. and included my coup de théâtre: a life-size rhino, which smashed through the side of a huge elevator, scattering fake glass everywhere and frightening those in the stalls.

THE MAGIC FLUTE

Papagena and Papageno costumes that I designed for Peter Hall's long-running production for Los Angeles Opera in 1991.

KARL LAGERFELD

For a documentary about Horst, the famous *Vogue* photographer of the 1930s, I interviewed various people in the fashion world: Paloma Picasso, Karl Lagerfeld, and Horst himself, in 1991.

FANTASTIC MR. FOX

SCARFE ON ART

After winning the BAFTA for *Scarfe on Scarfe*, I was regarded as a bona fide director. During this period I made a series of documentaries for the BBC, a comedy series for independent television, and others. But I decided after several years, to give up filmmaking—much as I loved it—because it was very time-consuming, and I felt that drawing and art were my true metier.

CANNES FILM FESTIVAL

Sent by *New Yorker* magazine to capture the scene in 1993, I drew many stars, including Arnold Schwarzenegger, who said, when I asked him to sign the portrait, "My lips are too big." To be fair, they were, but he signed anyway.

NEW YORKER

I worked for the *New Yorker magazine* for 15 years, under the editorship of Tina Brown, working regularly on large, full-page drawings of all types: films, plays, authors, historical figures and modern celebrities. Reportage of Wimbledon Tennis, and Cannes film festival, etc.

FANTASTIC MR. FOX

I designed costumes and scenery for this new opera based on the Roald Dahl novel. I had met Dahl years earlier to discuss a possible script for *The Wall*.

SCARFE AT THE NPG

I had a one-man show at the National Portrait Gallery in 1988. It was wonderful to see young school children lying full length on the floor, copying my image of Madonna wearing her iconic cone bra.

2000s

THE MILLENNIUM DOME 2000

Prime Minister Tony Blair promoted a gigantic exhibition of "all that is great in Great Britain." It was thought by some to be too laudatory, and I was hired to depict the other side of the coin. For instance, where the Dome said British sport was wonderful, I sculpted a football hooligan, with a boot for a head.

PETER AND THE WOLF, PARIS

I designed the costumes for the ice show version of the famous symphonic tale for children in 2000. Some of the skaters hated wearing my masks, as they couldn't see where they were going.

NINE ELEVEN

When the disastrous, shocking scenes of 9/11 hit our television screens, it was difficult to make a drawing for the *Sunday Times* of this horrific world-changing moment.

THE NUTCRACKER

I designed costumes and scenery for Tchaikovsky's ballet *The Nutcracker*, with my 5-year old granddaughter Ella in mind, making it fun and frothy. The snowflakes jumped out of a huge refrigerator: that sort of thing. Many critics loathed it: They wanted their traditional Nutcracker back. You can't win 'em all.

HEROES & VILLAINS

Another exhibition at the National Portrait Gallery, accompanied by a book depicting heroes of British history. Various contributors wrote short essays, one positive and one negative for each character.

CBE 2006

Queen Elizabeth II awards me the CBE for Services toward the Arts at a ceremony in Buckingham Palace. The Queen asked me 'Are you still at it?' by which I assumed she meant my art. I said yes. Then I had to take three steps backwards, bow and exit right. Tricky . . .

THE *NEW YORKER*

In 1991, I joined the *New Yorker* magazine when Tina Brown became editor, and for fifteen years enjoyed much praise and constant work. It was a heavenly relationship, but fifteen years later, it suddenly dropped off and ended. Nothing lasts forever.

COMIC RELIEF

As a charity, Comic Relief has raised millions for the relief of the starving, homeless, and suffering worldwide. My 2007 poster shows George W. Bush and Tony Blair as clowns.

2010s

THE TATE GALLERY

A wooden sculpture of Winston Churchill that I made for the political section—which I designed—of this exhibition of British comical art, Rude Brittania, showcasing my paintings and drawings. The Tate also built a replica of my studio desk, with all the ink, pens, paper, etc., scattered around.

HEROES & MONSTERS, GERMANY

I have had many one-man exhibitions around the world. This one in Hanover, at the Wilhelm Busch Museum, featured a wide range of my work in 2010.

ROGER WATERS LIVE

Roger Waters brought his updated show of *The Wall* back on the road, this time on a world-wide tour in 2012.

THE TEACHER

For his revamped tour of *The Wall*, Roger Waters and I created new inflatables of the now legendary characters including the Teacher, the Wife, and the Mother. This gigantic inflatable of the Teacher towers threateningly over the school children who sing "We don't need no education."

BILLBOARD

Celebrating his highly successful world tour, my cover drawing of Roger Waters for *Billboard* magazine in 2012.

CUSPICEPHALUS SCARFII

A British palaeontologist discovered the fossilized skeleton of an unknown pterosaur and asked me if he could give it my name, as its sharp beak reminded him of the way I always depicted Mrs. Thatcher.

SCARFE IN BOHEMIA 2012

Scarfe in Bohemia. It featured a retrospective of my work over the years, and of course *Pink Floyd: The Wall* drawings, which were known world wide.

SCARFE IN PRAGUE 2013

Another extensive retrospective this time in the beautiful city of Prague, featuring once again a selection of my work over the years, and the well-known painting and designs from *The Wall*.

SCARFES BAR

In 2014, I was asked by the international hotel group Rosewood Hotels, if I would lend my name to a bar in a new hotel they were planning and cover the walls with my oil paintings. It is now on the list of the 50 best bars in the world.

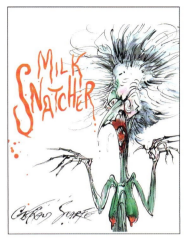

MILK SNATCHER

An exhibition at the Bowes Museum in Barnard Castle, England, of my many drawings of Mrs. Thatcher. She was called "milk snatcher" because of her early policy of discontinuing free school milk for young children in 2015. Looking back, I realize that Mrs. T. inspired many of my better drawings. She was my muse, I guess.

BREXIT

The front cover of the *Sunday Times* in 2016 after the disastrous day Britain voted to leave the European Union, showing the then prime minister, an appalled David Cameron, as the roulette wheel stops at "Leave." A huge mistake.

TRUMP

To a large extent, Donald Trump was my muse. His exploits were guaranteed to inspire strong and disturbing cartoons, including this one from 2016.

GROMIT UNLEASHED

The popular cartoon dog for Nick Park's Aardman studio in Bristol. A group of artists and designers were given the task of painting large plastic models of Gromit, in any style they wished. It was all for charity: Mine was called 'Watch Out Gromit!' It raised £50,000 for Nick's charity—the Bristol Children's Hospital. Very gratifying.

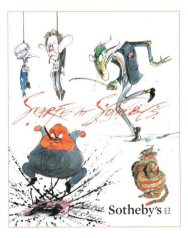

SOTHEBY'S

I was persuaded to put many of my drawings into an auction. Sotheby's gave me a fantastic and generous display in 2017.

SAN FRANCISCO

Through my gallery in San Francisco, I decided to sell a limited number of my very valuable, iconic Pink Floyd drawings in 2017. This one here, shown on a screen in Times Square, New York, received (I'm told) the highest price yet for rock art.

NEW YORK REVIEW OF BOOKS

Trump: Who will stop him? 2017. Looks like he's going to be around for some time!

2010s continued

STAGE AND SCREEN

A 2017 poster for the House of Illustration in London. A comprehensive exhibit of my theatrical works. Featuring my designs and costumes for *Pink Floyd: The Wall*, *The Magic Flute*, *Orpheus in the Underworld* and *The Nutcracker*.

PORTRAITS AND CARTOONS

Poster for Wilhelm Busch Museum fur Karikatur und Zeichenkunst in Hanover, Germany, 2018. Showing me posing with the then curator of the museum, my friend Dr Gisela Better-Libenow.

CENSORED

Victoria and Albert Museum exhibit, 2018 to 2019. The exhibition celebrated the fiftieth anniversary of the abolition of theatre censorship and explored theater, film, music, and censorship regulations. I have been censored many times for the contents of my drawings, usually on sexual grounds: rarely on political.

PLAUDITS

I came to the point in my life when I was being honored by universities and others for the body of work I have produced over the years. I received doctorates from Lincoln, Kent, Dundee, and Liverpool universities. Ironically, however much of a rebel one has been, it can be that society envelops you. I found myself becoming part of it and happily accepting plaudits and awards.

2020s

THE MAGIC FLUTE IN DALLAS

Tamino plays his magic flute to the hybrid animals. Still playing after all these years.

PRIVATE COMMISSIONS

Many Americans stay at the Rosewood Hotel, where my Scarfes Bar paintings adorn the walls. Some commission oil paintings for their homes, featuring members of their families or favourite celebrities. This particular painting is now in Texas.

THE SOKOL PRIZE, AUSTRIA

The Sokol prize was awarded to me for my lifetime achievement in the arts. Sokol was Austria's most prestigious artist of the last few years. I had a small exhibition of my work from 60's to the present day at Krems, a town near the beautiful city of Vienna.

PINK FLOYD'S THE WIFE

One of the oil paintings on display in my exhibition at Krems, Austria: an image of Pink Floyd's The Wife – still popular amongst fans, forty five years after I designed her in 1978. She was one of the many highlights of my varied career. After these 70 years I'm happy to say I am still working today in my studio.

I would like to thank John Musker, Ron Clements, Alice Dewey, and all the animators and crew who worked on *Hercules* and made it such an enjoyable experience.

A special thanks to my wife, Jane, for her work and support on this project.

I would also like to thank everyone who has been so helpful in producing this book:

Thomas Schumacher, Angelo Desimini, Vanessa Lopez, Sammy Holland, Adrienne Procaccini, Matt Girard, and Walt Disney

Rob Roth
Nick Park

Sian Rance at D.R. ink

Alex Scarfe

The Walt Disney Archives and Walt Disney Animation Research Library

Special thanks to my fellow artists and friends, who were so welcoming to me during my happy time at Disney.

And to the following for their encouragement and professional support:

FOR WORK APPEARING IN: *Billboard* magazine, *Daily Express*, *Daily Mail*, *Daily Mirror*, *Daily Telegraph*, *Encounter*, *Esquire*, *Evening Standard*, *Fortune* magazine, *Guardian*, *Independent on Sunday*, *Ink* magazine, *Life* magazine, *New Statesman*, *New Yorker*, *New York Review of Books*, *Private Eye*, *Punch*, *Rolling Stone* magazine, *Spectator*, *Sunday Times*, *Sunday Times* colour magazine, *Swill* magazine, *Talk* magazine, *Tatler*, *Time* magazine, *Times Literary Supplement*, *Vanity Fair*, *Vogue*

THANKS TO THE FOLLOWING GALLERIES:
Bowes Museum, Barnsley, Egon Schiele Art Centrum, Český Krumlov, The Grosvenor Gallery, London, The House of Illustration, London, Museum Kampa, Prague, Kunstmuseum des Landes Sachsen-Anhalt, Halle, Museum of Moving Image, London, National Portrait Gallery, London, Portcullis House, UK Parliament, Sears Vincent Price Gallery, Chicago, Sotheby's, London, Tate Britain, London, Victoria & Albert Museum, London, The Waddell Gallery, New York, Museum Wilhelm Busch, Hanover, Z Gallery, New York

www.geraldscarfe.com

INSIGHT
EDITIONS

PO Box 3088 San Rafael, CA 94912
www.insighteditions.com

Find us on Facebook: www.facebook.com/InsightEditions
Follow us on Instagram: @insighteditions

© 2024 Disney

ISBN: 979-8-88663-558-4

Publisher: Raoul Goff
SVP, Group Publisher: Vanessa Lopez
VP, Creative: Chrissy Kwasnik
VP, Manufacturing: Alix Nicholaeff
Editorial Director: Lia Brown
Art Director: Matt Girard
Senior Editors: Adrienne Procaccini and Sammy Holland
Assistant Editor: Emma Merwin
Executive Project Editor: Maria Spano
Senior Production Manager: Joshua Smith
Senior Production Manager, Subsidiary Rights: Lina s Palma-Temena
Text compiled and edited by Marc Sumerak

Designed by D.R. ink
Interview with author and transcript: Penelope Rance

ROOTS of PEACE REPLANTED PAPER

Insight Editions, in association with Roots of Peace, will plant two trees for each tree used in the manufacturing of this book. Roots of Peace is an internationally renowned humanitarian organization dedicated to eradicating land mines worldwide and converting war-torn lands into productive farms and wildlife habitats. Roots of Peace will plant two million fruit and nut trees in Afghanistan and provide farmers there with the skills and support necessary for sustainable land use.

Manufactured in China by Insight Editions

10 9 8 7 6 5 4 3 2 1